The Lamar Series in Western History

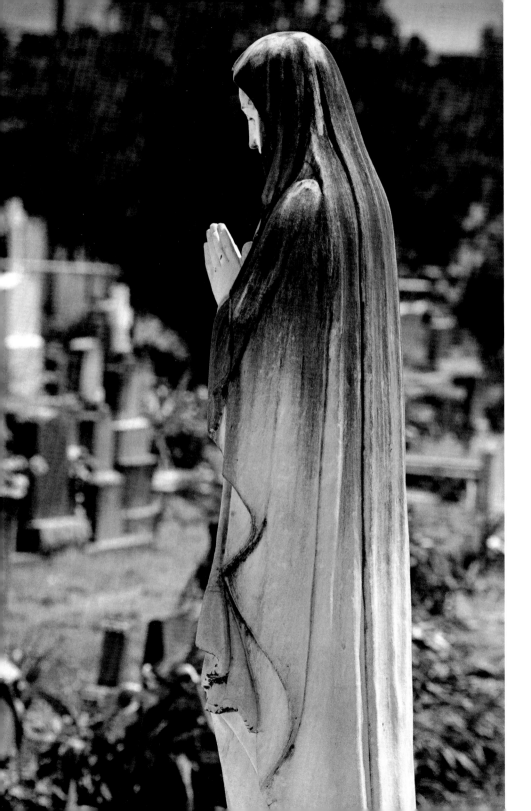

Bordertown

THE
ODYSSEY
OF AN
AMERICAN
PLACE

Text by

Benjamin Heber Johnson

Photographs by

Jeffrey Gusky

YALE UNIVERSITY PRESS

New Haven & London

Published with assistance from the Kingsley Trust Association Publication Fund established by the Scroll and Key Society of Yale College, and from the Louis Stern Memorial Fund.

Designed by Sonia Shannon.
Set in Emigre Filosofia by Duke & Company, Devon, Pennsylvania.
Printed in Canada by Friesens.

Library of Congress Cataloging-in-Publication Data
Johnson, Benjamin Heber.
Bordertown : the odyssey of an American place / text by Benjamin Heber Johnson ; photographs by Jeffrey Gusky.
 p. cm.
Includes bibliographical references and index.
ISBN 978-0-300-13928-0 (alk. paper)
1. Roma (Tex.)—History. 2. Roma (Tex.)—Biography. 3. Roma (Tex.)—Social life and customs. 4. Roma (Tex.)—Pictorial works. 5. Mexican-American Border Region—History. 6. Mexican-American Border Region—Biography. 7. Mexican-American Border Region—Social life and customs. 8. Mexican-American Border Region—Pictorial works. I. Gusky, Jeffrey. II. Title.
F394.R66J64 2008
976.4'485—dc22 2008017942

A catalogue record for this book is available from the British Library.

10 9 8 7 6 5 4 3 2 1

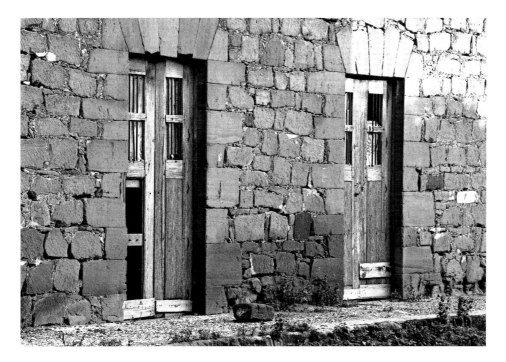

for Michelle

B H J

to Dr. Rubén Rodriguez and Noel Benavides,
who made this book possible

J G

CONTENTS

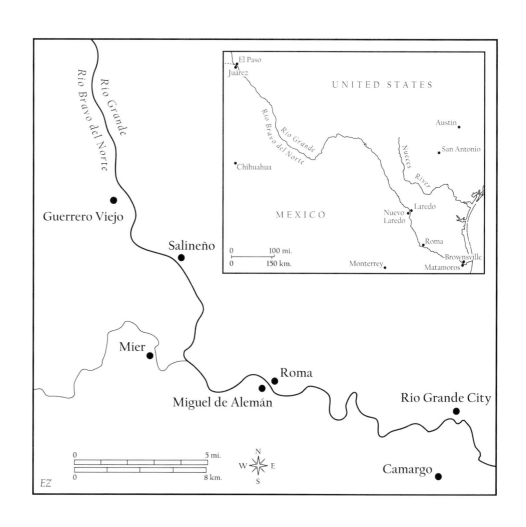

Rio Grande

Rio Bravo del Norte

Guerrero Viejo

Salineño

Mier

Roma

Miguel de Alemán

Rio Grande City

Camargo

0 5 mi.
0 8 km.

EZ

N
W E
S

El Paso
Juárez

UNITED STATES

Rio Bravo del Norte

Rio Grande

Nueces

River

Austin

San Antonio

Chihuahua

Laredo

Nuevo
Laredo

Roma

Brownsville

MEXICO

0 100 mi.
0 150 km.

Monterrey

Matamoros

THE SPANISH WORD FOR "border" is *frontera*. Frontier.

So many depictions of places like Roma, Texas, focus on decadence and debauchery. Certainly, the Mexican locales are alien—you might as well be looking at photographs of Darfur or listening to news coverage from Basra. You see the southwestern borderlands like a tourist passing through Hell.

This has always seemed unfortunate to me. After all, as the subtitle of this remarkable book points out, they are *American* places. Haunted by our shared history, alive with the same light as our hometowns. To see them as less than part of us is to dismiss our own history. To be from the Mexican territories is not a shameful thing, it is a beautiful thing.

To look at these images is to look at the ghosts of the western frontier.

If you drive into the Badlands of South Dakota, you will see hand-painted signs along the road. Some of them urge you, Feed the Prairie Dogs, at a roadside attraction near the edge of the park. Not far from this happy prairie dog kingdom, you will see another set of signs that invite you to see a real sodbuster's shack. What could be more American than a pioneer, a sodbuster's soddy, a dugout on the unforgiving western trail?

We pulled in and paid our entry fee and wandered among old farm equipment. There were chickens everywhere, which must have been the same when the brave pioneers made their hut. And up a short rise, there it was, dug into the hill. The

door was low and slightly crooked, but I could see the evidence of craftsmanship. The nails were still there, the pegs, the gouges in the wood.

I took off my hat and ducked into the doorway and stood there on the dirt floor feeling reverent: here was a great myth exposed, here were the wraiths of our past. The little crooked table, the mismatched chairs and improvised furnishings, the slats and newspaper pages on the walls, holding back the dirt. The old slouchy bed. And the musty smell, vaguely herbal, of the sod and the dry wood.

It hit me like a blow: I had seen these same things before. I had seen this exact shack. This bed. This floor. These chairs. I had seen this shack in Tijuana. Pioneers headed north had built this same hut.

I had seen this shack in Arizona. I had seen it in west Texas. I had seen it in California.

Nobody had put up a sign or a historical marker. No one charged admission. No one had written limpid prose about the brave homesteaders advancing Manifest Destiny.

It was a different myth. Because this one was ours, was American, it was beautiful. Because that one was theirs, Mexican, it was tawdry. *We came here legally,* people like to tell me. Of course, here at the Badlands, nobody asked Crazy Horse or Red Cloud for their opinion.

Consider Roma.

People lived here for hundreds of years. Imagine waking up one morning and learning that the Mexican government had sold the northern half of the country to the United States. Imagine waking up one day an alien in the land you had lived

in all your life. As the old political *mot juste* points out, "We didn't cross the border—the border crossed us."

Jeffrey Gusky's photographs and Benjamin Johnson's stories are haunting and elegiac. At once stark and deeply felt, they are powerful and true. These lands and their people are beautiful in their severe grace.

They are truly American.

It's your own homeland.

<div align="right">LUIS ALBERTO URREA</div>

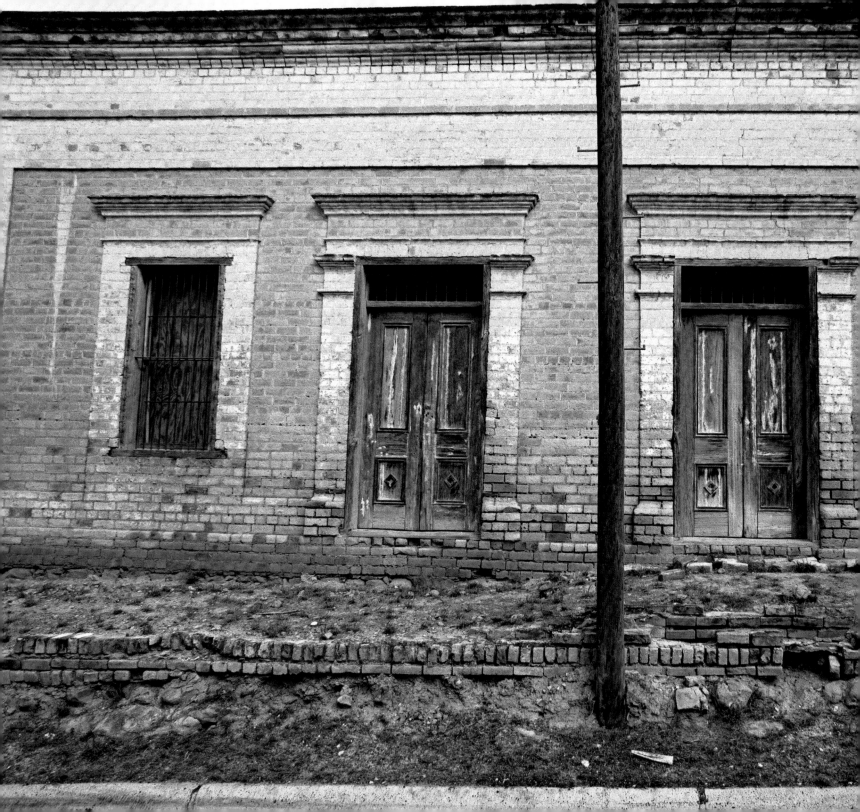

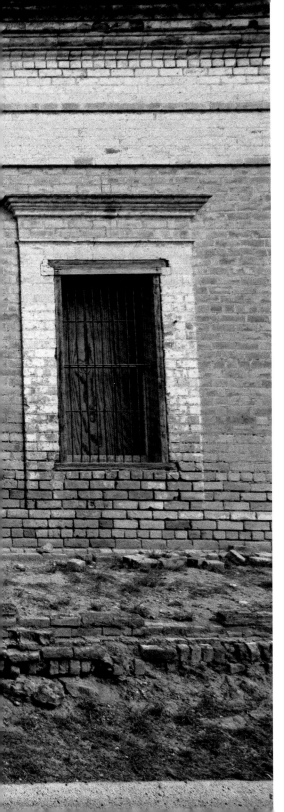

AMERICA WAS MADE HERE, TOO.

Most people just passing through would never guess it: on the surface, Roma, Texas, looks like a lot of small towns fallen on hard times. The blown newspapers, crumpled beer cans, and dirty water standing by the road after even a light rain all suggest that this place is poorer than most, as indeed it is. There are more than a few boarded-up and abandoned buildings. Most of the crowded businesses on the main drag are national chains based in cities far away—Burger King, McDonald's, Dollar General. Their glowing signs seem to say that whatever money, power, or dreams this place generates go far away fast.

Clearly distant from power and wealth, the town can also seem equally remote from the United States. Spanish is the dominant language here, announcing sales on marquees, coming over the radio from talk shows, in music, and on television programs broadcast across the river. Mexican food is all there is to eat, unless you go to one of the fast-food chains for a burger or salad. The town is right on the Rio Grande, about halfway between Laredo and Brownsville. Nearly all the residents are of Mexican descent, as has been the case since this region—through no choice of its own—became part of the United States.

If you get off the main highway, though, and know what you're looking at, and talk to some of the people whose families have lived here for as long as this has been a place, you can see the signs and hear the stories of a different past, one that speaks as much of power as of poverty, of the United States as well as Mexico. Some of the

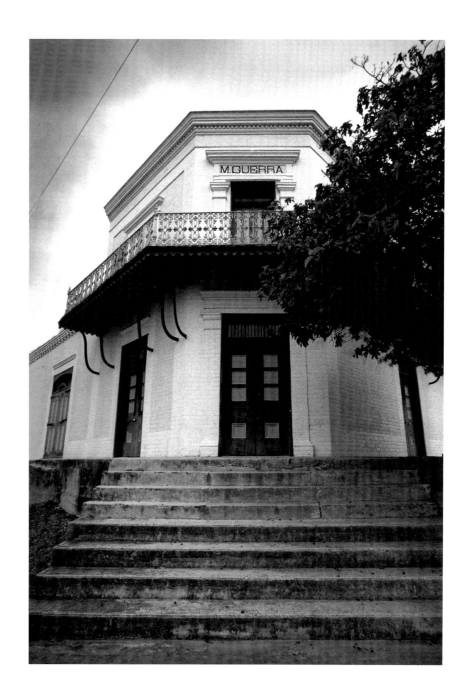

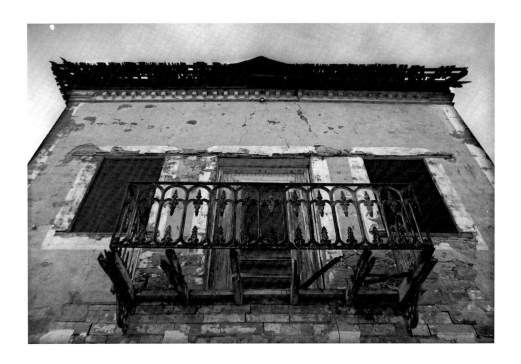

most obvious clues to this hidden history lie in the old buildings clustered around
a long and rather narrow plaza that backs onto the high bluff overlooking the river.
The plaza is quiet these days, and its mostly dilapidated buildings are well over a
century old. But the prosperity, confidence, and workmanship of the people who
created this place are still obvious. In sharp contrast to the drive-ins on the state
highway, these buildings are not quite like any others in the United States or Mexico
outside of this region. Find a knowledgeable resident, like the proprietor of the
J. C. Ramírez Store a few blocks away, and you'll hear about how one of the Civil

War's least-known but most important dramas played out here, helping to create the plaza's distinctive buildings. Talk to others and you'll hear of how Hollywood came to town ninety years later. Director Elia Kazan thought the town was perfect as a stand-in for Emiliano Zapata's village, and so the millions of Americans who saw his film and cheered as Anthony Quinn earned himself an Academy Award had actually seen Roma and those of its residents hired as extras.

There are other signs, too, of how this place and others like it shaped and shape America, signs that point to the more recent past and even perhaps our future. The cemeteries—remarkably well tended for such a poor place—memorialize the departed with statues of supplicant angels, simple and more ornate headstones, Spanish inscriptions, countless U.S. flags, and the slogans and icons of Mexican fraternal lodges and American patriotic clubs alike. The Catholic Church sits at the top of the plaza, within earshot of the Pentecostal services in a former movie theater a few blocks away that are some of the few signs of life in this once vibrant historic district. The flowers and crosses on the highway where six of the town's children perished in an awful wreck a decade ago look a lot like the roadside memorials proliferating all over the country.

Somehow this place is both Mexican and American. There is an unbroken chain to the Mexican and Spanish past here—friends can go to cemeteries across the river and find their family names on gravestones from several centuries. Yet the town gives its young to our wars, and one of its most prominent citizens once graced a pro-military rally by singing a karaoke version of Lee Greenwood's "Proud to Be an American" on the church steps. For years the priest kept the church open to migrants, legal and otherwise. Yet he was deposed for this by the town fathers, themselves bilingual border crossers. This place has changed as much as anywhere else

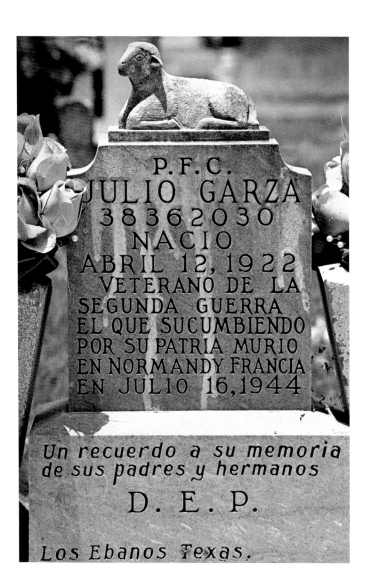

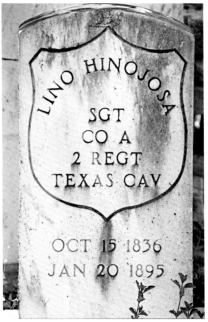

in the country, as the gulf between the world that created the plaza and the world that created the Burger King suggests. Yet the family names on the church windows and pews, built in the 1960s, also dominated the tax rolls and newspapers a century ago.

To walk through this town and its history, as this book does, is to walk on ground at once intimately familiar and exotically strange to most Americans. It is to glimpse our future not just as the unfolding of scripts written far from here, but also to see how people who live in and travel through places like this have shaped the United States and will continue to do so in the decades to come. The first surveyors of the U.S.-Mexico boundary passed through here, attempting not only to map the border but also to explain these odd regions to the nation's population and power centers back east. Some local families rose to wealth and prominence, shipping the Confederacy's cotton to world markets by way of Mexico, even as others joined the Union army. Locals welcomed Belgian priests and a German architect into their world, learning from these highly educated outsiders as they incorporated them into their own language, culture, and even families. Where people of Mexican descent in most of the rest of the Southwest were stripped of land and voting rights, here they maintained economic dominance and political power, at times deciding statewide elections under dubious circumstances, as when a South Texas ballot box made Lyndon Baines Johnson a United States senator. The region has sent its sons and daughters to all branches of the military, in greater proportions than almost anywhere else in the country. Its Hispanic majority made it an almost freakish anomaly to many other Americans—a century ago one army officer called it "the American Congo"—but its residents have seen Anglos again become a minority in the entire state of Texas. The town's young adults and children will live to see the day when one quarter of Americans claim Hispanic descent.

This has never been a big or famous place, but as more than one local has remarked, "in Roma, nothing happens, but everything happens."

Outsiders have come to the border since its creation, in search of one thing or another. Some came because they had to, driven by economic desperation to the factories of the maquila zone, or sent by the federal government to crush those who refused to accept that this part of the earth now belonged to the United States, or more simply but less easily ordered to police the line and keep some people or some things from crossing it. Others came because they wanted to, drawn to seek the riches they saw in visions of oil wells or longhorns as far as the eye could see, or delighted to find a border town where the restrictive rules of their own society seemed not to apply, where money could more easily be exchanged for liquor, sex, or drugs.

More than a few came with a mission similar to ours, the notion that they might glean something of their country's future in the present and past of seemingly remote places like this. These observers have seen everything here that they've wanted to. Mexican travelers often dismissed borderlanders as *pochos*, or "bleached," a

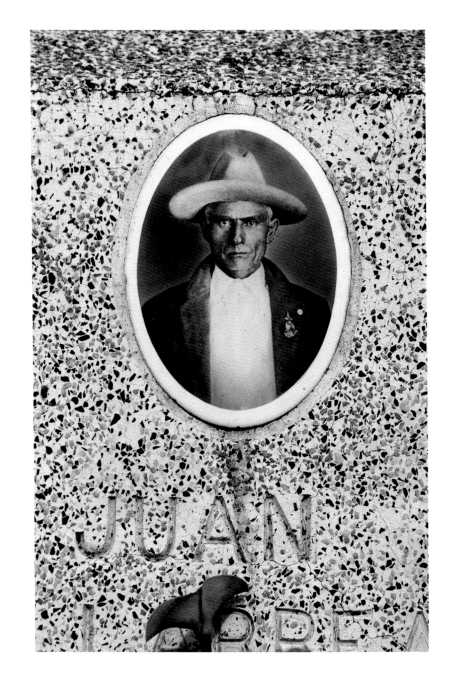

confused and aimless people neither American nor Mexican. More than a few
Americans saw a decadent and barely civilized people living in filth, soon to be swept
away as Western civilization marched triumphantly across the continent. Others,
both Mexican and American, looking at runaway industrial growth, polluted water-
ways, and the graves of migrants and murder victims, saw such chaos and corruption
that they feared the border captured only the worst of both countries. Others have
been enraptured with the new places and people they encountered, seeing in them a
way of inhabiting the earth and even a spirituality that they couldn't find in their own
culture. The history of the encounter between these interlopers and this small town
is a microcosm of the history of the border in the life of the United States. To under-
stand this place, the people who made it, and the ways that other outsiders have
understood them, is to understand how the border has helped make America. That
is the story we tell here.

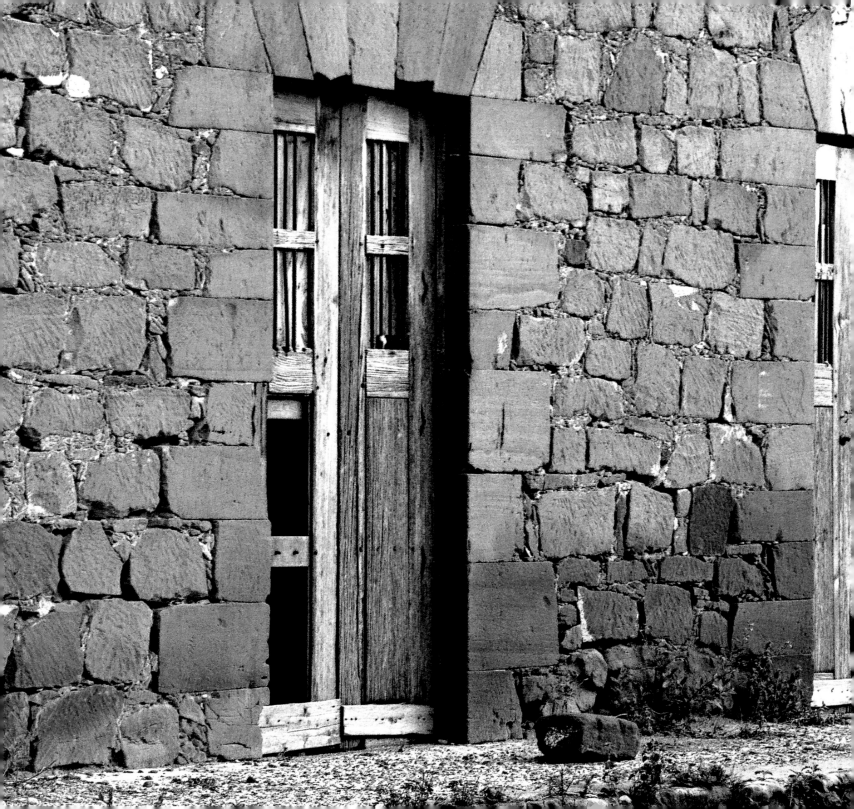

William Emory

A STROKE OF THE PEN was all it took to create the border. In 1848, the victorious
army of the United States, encamped in Mexico City's central plaza, redrew the map
of North America. Mexico, brought to its knees by the invading forces, had no choice
but to cede its northern half, from the coastal missions of Alta California on the
west, to the Rio Grande settlements in New Mexico, to the towns of Texas (whose
independence a decade earlier it had never acknowledged) on the east. The lines
on the new map showed that this vast new territory was now part of the continent-
straddling United States. But what seemed clear on paper was another matter
on the ground. It was one thing to claim such a territory, and another to actually
control it.

This was one of the many discoveries that William Emory made in the years
that followed the signing of the Treaty of Guadalupe Hidalgo. Emory, the scion of
a wealthy Maryland family and a graduate of West Point, was appointed as one of the
commissioners of the U.S.-Mexico Boundary Survey. The survey's task was decep-
tively simple: to map the new border, which was to follow the main channel of the
Rio Grande (known to Mexico as the Río Bravo del Norte) to a point upstream of
El Paso, from there west to the head of the Gila River, and from that point west to
the Pacific. In a larger sense, Emory's task was to introduce this huge new territory
to his countrymen. What did it look like? What were the best routes to travel through
it? What was its potential for agriculture, mineral development, and trade? Who

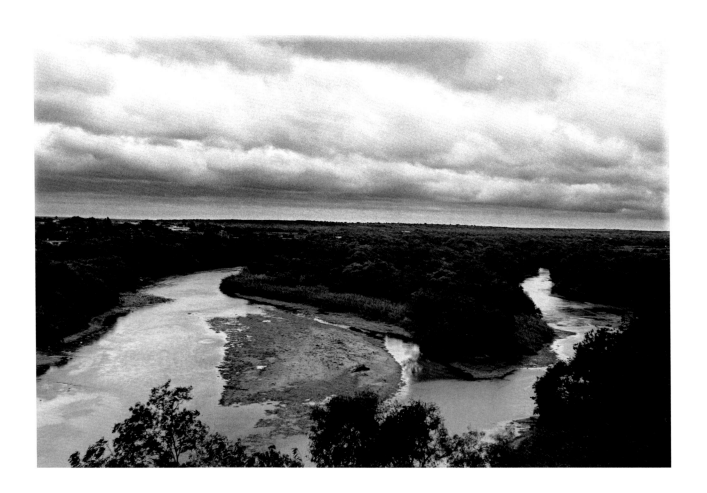

lived there? How would they greet American settlers? In short, how would Americans incorporate this vast new domain?

William Emory's quest to answer these questions was backed by the federal government of the United States of America. Two generations before, this entity had been a weak conglomeration of states huddled on the Atlantic seaboard; one generation before, it had been unable to prevent the armies of its former imperial master from burning much of its capital city. Now it had become an empire in its own right, one whose forces had started a war sixteen hundred miles from its capital, fought across hundreds more miles of desert and mountain, crushed its rival's army, and occupied the grand colonial buildings of Mexico City, one of the world's largest metropolises long before the Puritans had settled in North America.

William Emory's straightforward tasks proved exceptionally difficult to execute. The survey was to begin near the old Spanish mission at San Diego, California. But because the land route across the continent was so grueling and dangerous, the U.S. party opted to sail to Panama, cross the narrow land bridge there, and sail to California. The journey to Central America was uneventful, but once the U.S. commissioners arrived there in March 1849, the flood of traffic prompted by the California gold rush delayed them for two full months, exhausting much of their funding in the process. Quarreling over finances was joined by a deeper split within the U.S. side of the commission, with the northerners, including Rhode Island's John Russell Bartlett, suspicious that southerners were intent on finding a southwestern route for a transcontinental railroad, thereby ensuring the spread of slavery westward.

It was not until four years later, in the summer of 1853, that mapping of the Rio Grande section of the border began. Even this was hard to pull off: yellow fever killed the party's doctor—and nearly Emory himself—while they awaited transport in

Florida. Hurricanes turned the journey across the Gulf of Mexico, which usually took five days, into an eighteen-day ordeal. Once on land, the party depended on the protection of the U.S. Army from the Apache, Comanche, and other Indian peoples, who seemed not to know or care that their lands were now claimed by the United States. Some of the river proved simply impossible to survey. The rugged terrain of the Big Bend country struck Emory with its desolate beauty. "No description," he wrote, "can give an idea of the grandeur of the scenery through these mountains. There is no verdure to soften the bare and rugged view; no overhanging trees or green bushes to vary the scene from one of perfect desolation." The qualities that made the area visually striking precluded its adequate mapping, however. "Rocks are here piled one above another," continued Emory, "over which it was with the greatest labor that we could work our way. The long detours necessarily made to gain but a short distance for the pack-train on the river were rapidly exhausting the strength of the animals, and the spirit of the whole party began to flag. The loss of the boats, with provisions and clothing, had reduced the men to the shortest rations, and their scanty wardrobes scarcely afforded enough covering for decency. The sharp rocks of the mountains had cut the shoes from their feet, and blood, in many instances, marked their progress through the day's work." In the face of such hardship, the commission headed south into Mexico, leaving this stretch of the border unsurveyed.[1]

Despite these enormous and frustrating obstacles, William Emory and his Yankee counterpart John Bartlett had tremendous confidence in the ability of Americans to take this vast territory into their possession and transform it to suit their own purposes. Each man's report (published separately in the 1850s) confidently noted the

most promising sites for mineral development, the best grazing grounds, the places best suited for planting wine grapes, and the richest agricultural lands. An empire would surely be made here. "Does not the certainty suggest itself," another American visitor who traveled the borderlands in the 1850s rhetorically asked, "that before many years the American people, proverbially ambitious and restless as they are, will spread themselves over this hidden paradise?"[2]

Roma fit comfortably into this perspective. John Bartlett narrowly missed the town; heading toward the Gulf of Mexico on the Mexican side of the boundary, he

simply noted seeing the town from across the river, which he crossed seventeen miles downstream at Rio Grande City.[3] William Emory, however, stayed the night in Roma, which he praised as a "beautiful town . . . built on a high bluff of yellowish sandstone." (His report included an attractive watercolor of the bluff.) Here the surveyor, impressed by the "fine residences and warehouses, all recently built," found signs of growth and prosperity rather than decay and decline. A small set of solidly constructed buildings stood on the bluff overlooking the river and the boat landing at the cliff's foot. The merchants in these buildings conducted a lively trade with soldiers, Anglos coming into the region in search of fortune, and nearby Hispanic ranchers.[4]

Much of the American commissioners' confidence in the future prospects of the Southwest derived from their singularly low estimation of the culture and capacities of those who inhabited it. Commission members disagreed on many points—so much that some would find themselves on opposite sides of the Civil War a decade later—but were in accord in their contempt for the native people they encountered. Early in his beautifully illustrated report, Emory emphasized that the country he traveled through was "uninhabited by civilized races, and infested by nomadic tribes of savages." The fiercely independent and still-powerful Indians frightened and angered him the most, but he also held a low regard for the Hispanic ranchers who had settled most of the length of the Rio Grande. Indeed, they did not even fall into the category of civilized people: "Although the Rio Bravo, from El Paso to its mouth, has been frequently mapped," he noted, "it will surprise many to know, that up to the time when I commenced the survey, by far the largest portion of it had never been traversed by civilized man."[5] Emory's northern counterpart was not quite as

dismissive, but he did emphasize the contrast between Spanish and "Anglo-Saxon" pioneering. Bartlett noted with pride that it had taken Anglos only a decade to make Ohio, Indiana, Illinois, and Michigan richer and more populous than Texas, New Mexico, California, Sonora, and Chihuahua had become after two centuries of Spanish and Mexican rule.[6]

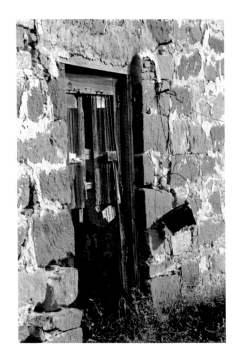

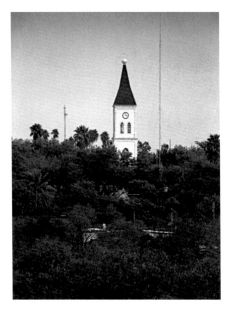

Both Emory and Bartlett had to acknowledge the past glories of the Spanish Empire. Their own sufferings and difficulties in the region led them to respect the struggles of those who had come before them with the harsh climate and stubbornly independent Indians. Bartlett was the most explicit and poetic in comparing the Spanish and American frontiers. "There is no portion of the early history of this continent," he pronounced, "whether it be that of the first establishment of the pilgrims in New England, the labors of the zealous Catholics in Canada, or the planting of the colonies in Virginia, that can vie with the extraordinary adventures and sufferings of the pioneers who first traversed the broad prairies and deserts of the central portions of our continent." The Spanish priests and explorers could hold their own with the iconic founders of the United States, for "long before the consecration of Plymouth Rock, the religion of Christ had been made known to the Indians of New Mexico; the country of the buffalo was visited; the Rocky Mountains were scaled; and the Gila and Colorado Rivers, which in our day are attracting so much attention as novelties, were passed again and again by the persevering and energetic Spaniard. The broad continent, too, to cross which, with all the advantages we possess, requires a whole season, was traversed from ocean to ocean before Raleigh, or Smith, or the Pilgrim Fathers had touched our shores."[7]

To admire the Spanish past, however, was not to admire the Mexican or Indian present. The ruins of missions and forts spoke not only of Spanish greatness, but also of decadence and decline. And for William Emory, as for most white Americans at the time, the foremost fact about the Hispanic pioneers he encountered was that they were not white. "Nine-tenths of the population of Mexico are Indians," he declared, "or have the blood of Indians coursing in their veins. A pure white, of unadulterated Spanish blood, is rather the exception than the rule." (Many of the early

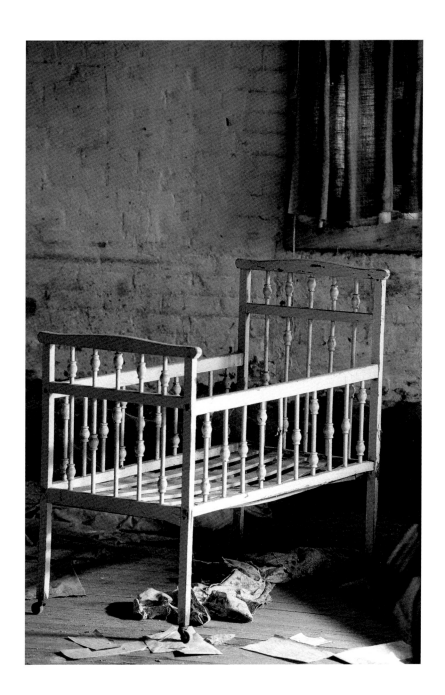

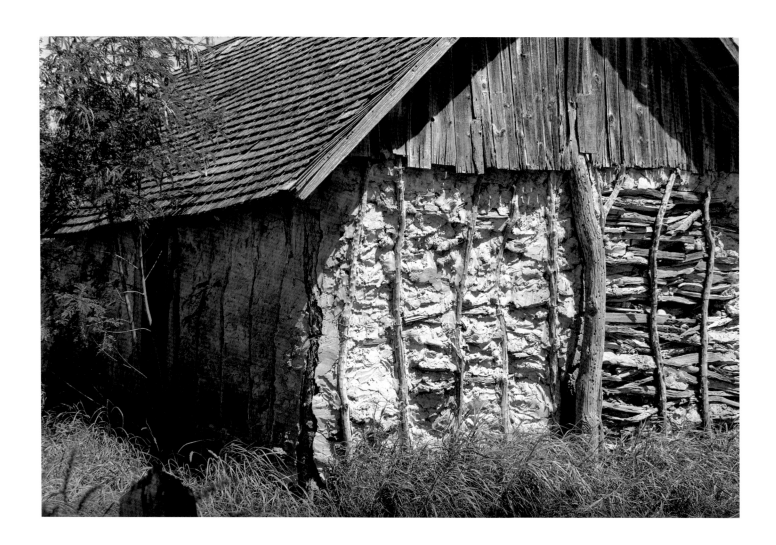

settlers of Roma and the rest of the Mexican north would have disagreed vigorously, insisting—generally inaccurately—that they were of pure Spanish descent.) This impurity, reasoned Emory, was the very reason for the decline of Spain's empire and its replacement by the vigorous and white United States. As Emory explained, "the attempts at amalgamation, by intermarriage of the whites and Indians," accounted for "the decline and retrograde march of the population of the entire region." He warned Americans not to repeat this mistake, but rather to populate their new territory with whites of both sexes, which he cheerfully predicted would "result in exterminating or crushing out the inferior races, or placing them in slavery."[8]

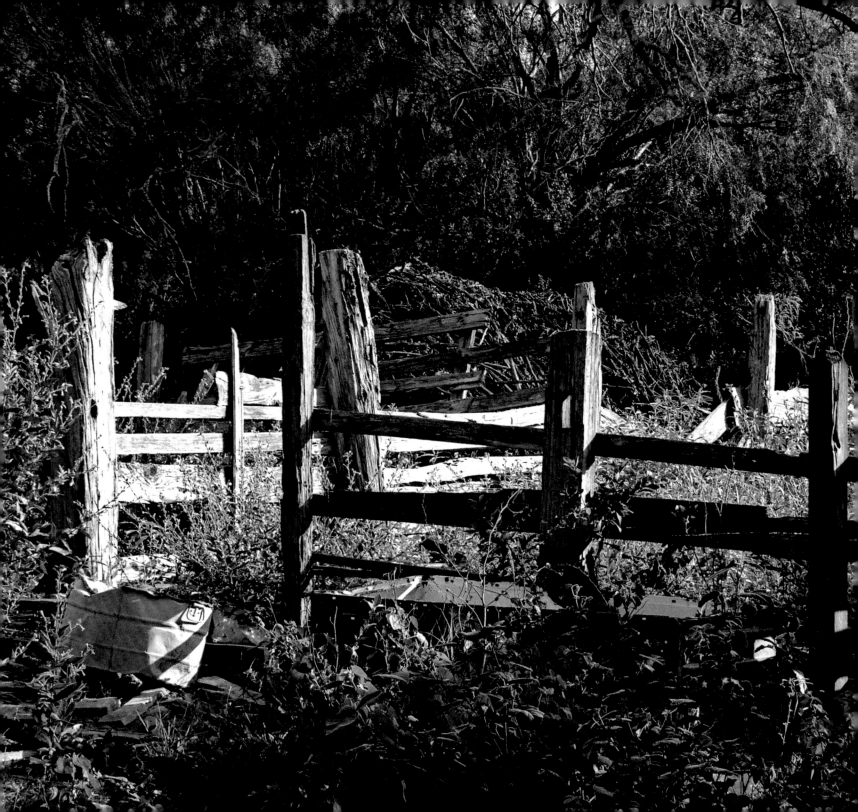

José María García Sáens

WILLIAM EMORY AND JOHN BARTLETT probably never met José María García Sáens when they passed through South Texas, but if they had stopped to spend much time with him or his kinsmen they might have found reason to doubt the likelihood of the disappearance or enslavement of northern Mexico's pioneers. García—Hispanics traditionally bear the last names of both father and mother but are commonly known by the first of these, to the lasting confusion of Anglophone journalists and scholars and their library catalogues and Internet search engines—was born in the late eighteenth century, when Spain still ruled Mexico, and would help found Roma shortly after the United States annexed the north bank of the Rio Grande.

García's family and the others who founded Roma were in many respects similar to the Anglo pioneers whose virtues William Emory celebrated. They too were an expansive, self-confident people who had brought their civilization to one of the continent's severest and most remote places. If British North America, and the United States after it, had a west, then Mexico had a north. More arid, harsh, and rugged than the Aztec and Mayan cores to the south, it nonetheless beckoned settlers and missionaries with new lands and opportunities.

Most Hispanic settlers of what became South Texas in 1848 had migrated up from Nuevo León, settled by the Spanish at the very end of the sixteenth century. The province of Nuevo Santander, which included the lower portions of the river that Americans would later call the Rio Grande, was formally established a century and a half later when settlers and soldiers under the leadership of José de Escandón

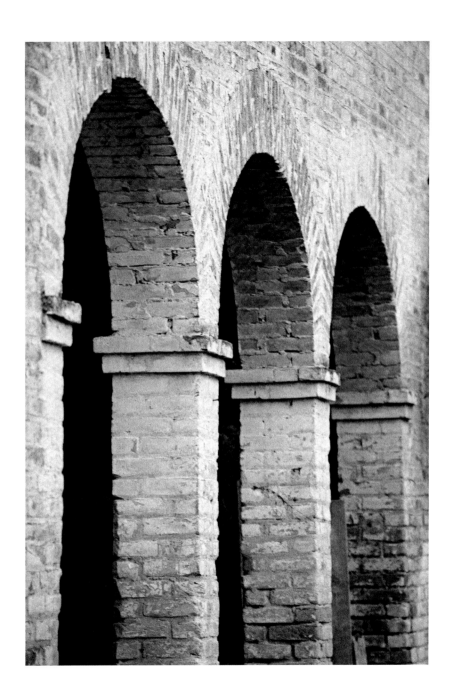

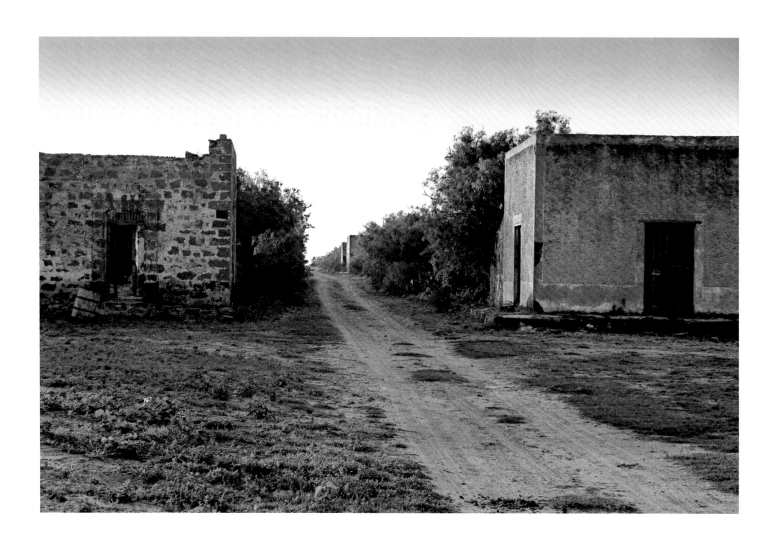

carved out two dozen settlements from the last portion of northeastern Mexico to fall under Spanish control. The province's northern boundary, the Nueces River, was the southern boundary of the province of Tejas, founded in the 1710s. After two generations, Nuevo Santander's settlers numbered more than thirty thousand— about the same size and growth rate as the English colony of Georgia, founded a decade before Nuevo Santander, and far larger than Texas.[1]

Modest population growth and the continued draw of abundant grazing lands prompted the establishment of new towns and ranches, as in the 1760s when García's grandfather, one of the first generation of Hispanic settlers in the region, received a grant of land stretching north from the far bank of the Río Bravo. For a time the family continued to live in the town of Mier, across the river and ten miles to the west. They probably ran cattle and other stock on the land that they dubbed Rancho de Jesús de Buena Vista out of regard for the same bluff that later impressed William Emory. At some point a portion of the family made a home on the rancho, and by 1812 four related families, including García's, lived there.[2]

The very shape of these grants reflected the values and aspirations of this frontier Spanish culture. Where the Coahuiltecan Indians into whose homeland the settlers moved demarcated their shifting territories in circles roughly measured by travel distances from places distinguished by their fertility or the shelter they offered, Hispanic settlers measured most of their territory in the straight lines and formal boundaries that allowed land to become property. These lines, however, were drawn as much to meet the demands of settling and living in a place as to convert it into a rapidly traded commodity. The tracts that García's grandfather owned were called *porciones*, long, narrow strips that stretched away from the river to arid and exposed grasslands. The shape of a *porción* and the way that it encompassed

different ecological niches promised its owner and his family access to water for themselves and their livestock, more fertile ground near the river for crops, thicker timber for construction, and some rangeland for cattle, sheep, and goats.

Porciones were property—they could be bought and sold and traded, and were—but most of all they were designed to create stable, permanent, and independent communities. Communal grazing lands were assigned to towns, as had once been done in Puritan Massachusetts. Most rangeland was held in common pastures open to all. Even tracts initially allocated to a single owner, such as García's grandfather,

were in practice soon collectively owned by descendants. Spanish law and custom did not recognize primogeniture and accorded women much greater property rights than did English common law, helping to make extended families rather than individual proprietors the key economic actors.[3]

Had García ventured into what was then the West of the young United States, he would have found a recognizable but puzzlingly different pattern upon the landscape. The U.S. township survey system, later to be painfully and awkwardly superimposed on the Spanish system in the Southwest, was much more oriented at creating abstract, interchangeable squares fluidly tradable in a market. A brief look from an airplane window today still reveals the contrast: the long, narrow strips of the porciones are visible along much of the lower Rio Grande (and near New Orleans, where the French employed a similar system), whereas the squares and sharp corners of the American Midwest bisect lakes, rivers, and watersheds with splendid indifference.

The acreage that the García family owned would have astonished American yeomen farmers and Mexican peasants alike. A single porción, for example, was 8,677 acres, more than enough for a rich hacienda or plantation in the continent's more productive climes. But the aridity and harshness of this country made a porción a much more modest tract, mostly suitable for low-density stock grazing. Given the extent of their landholdings, García's parents and grandparents probably enjoyed somewhat greater wealth and higher social standing than did most in Nuevo Santander, but they were by no means rich. Because Escandón relied on willing migrants rather than royal soldiers or religious orders to settle Nuevo Santander, large land-hungry missions and elite haciendas were very rare. It was thus easy for most of the colonists to own land, with leaders amassing tens of thousands of acres of pas-

tureland and several thousand acres of much more valuable irrigable land for crops. All of the original male settlers received substantial grazing and irrigable lands, with more recent arrivals able to claim only several thousand acres of grazing land. Serfs or *peones* attached to the province's few haciendas were landless, as were the dwindling Coahuiltecan populations attached to the region's few missions. Social life reflected these differences. Ranch cemeteries, for example, were generally segregated by class, and the daughters of the wealthiest families would be unlikely to attend the dances that brought together more modest sorts from miles around.[4]

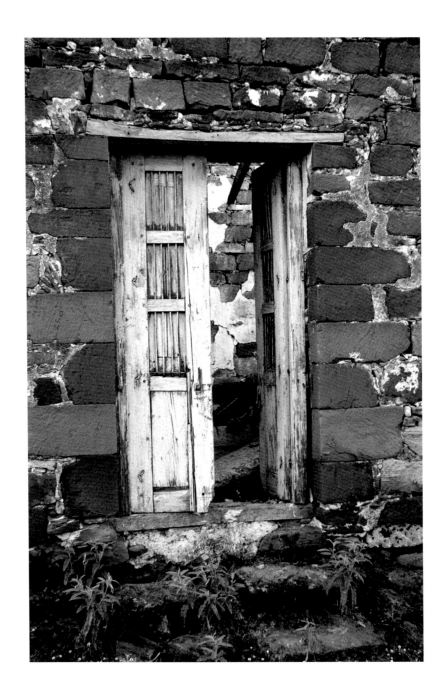

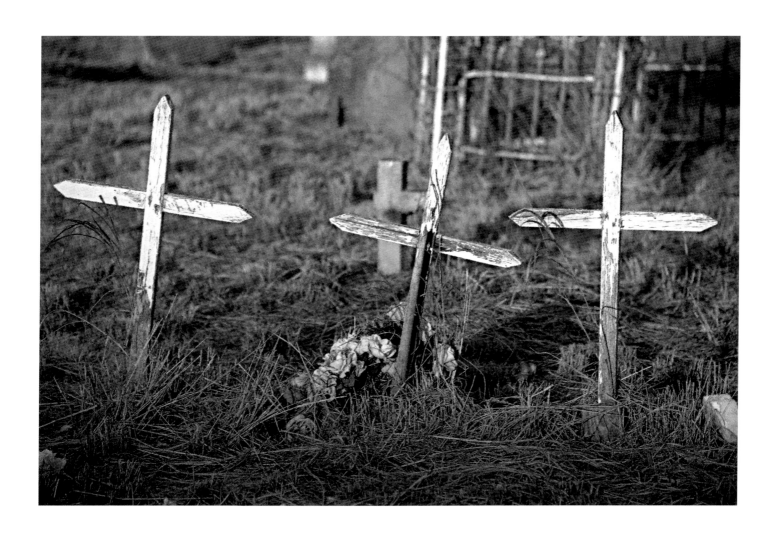

The abundance of land meant that families like García's—and most ranching families—enjoyed much more independence and social standing than did Mexico's peasants or the United States' slaves and landless agricultural laborers. (Even a peon, at the bottom of the Hispanic hierarchy, "eats with his master and is almost similarly clad; and it is hard at first to distinguish the one from the other," a Catholic missionary observed in the 1840s.) But nobody's life was easy. Residents had to produce most of the necessities of life with their own labor, growing the traditional Mexican trinity of corn, squash, and beans near their homes, raising stock for milk and meat, and constructing buildings out of the region's stones and scarce timber. They shipped hides from the abundant and generally semi-feral cattle to Nuevo León and later New Orleans in exchange for corn, wheat, and the scarce luxury goods like china or fine linen that were the exclusive province of the elite. Even their clothing was mostly homespun. With constant physical labor in a harsh climate that featured months of searing temperatures, it was little wonder that many church and town names included the word *refugio,* or refuge.[5]

García and his ancestors brought a rich and complicated culture to meet the challenges of frontier life, one that encompassed the colonial trajectory of New Spain, stretching all the way back to the diverse peoples of the Iberian peninsula. A trained eye can still see the signs of this trajectory in the remains of the oldest buildings along the lower border. Rainfall was unreliable, digging wells was killing labor, and hauling water from the river was exhausting and prohibitively far for many ranches, so artfully designed *bajadas* on roof edges captured precious rainwater and funneled it down to cisterns. The local word for these reservoirs, *aljibe,* was derived from Arabic, as were many irrigation techniques. Their structures, even before the rise of extensive commerce in the nineteenth century and the greater prosperity it

brought, were brilliantly adapted to give shelter and comfort in the region's brutal summers and fickle winters. This was true even of the *jacal,* northern Mexico's equivalent of the log cabin, a simple structure with walls of vertically arranged mesquite logs, mud wattle, thatched roofs, and swept dirt floors. (A brief respite in one of the region's few remaining *jacales* in the heat of the day confirms the skillfulness of their design.) Other objects revealed hints of other influences: the surprisingly frequent presence of Jewish material culture—candelabras and small stacks of stones

on graves—suggested that *conversos* from Spain and northern New Spain numbered among these settlers' ancestors.

Like their Anglo-American frontier counterparts, García and his people did not think that Indians had much of a place in their culture. Coahuiltecans, generally pacific and in any event poorly armed and widely dispersed, posed no particular threat and could thus be tolerated as neighbors. Apaches and Comanches were another matter. Comanches, an imperial power in their own right, became the Southern Plains' dominant military force in the decades following Nuevo Santander's establishment, dramatically expanding their reach and subjugating much of the Mexican north to their military and economic power. Heavily fortified ranch houses, with high windows and narrow slits for gunports, were one reflection of the fear brought by Comanche raids to seize captives and livestock that shook the region in the decades after José María García's birth.

Beneath the surface, however, Mexico's Indian peoples also left their mark on García and his kinsmen. Classic Nahua motifs like circular flowers from Mexico's Aztec core to the south could be found on the architectural details of churches and more elaborate homes, reflecting the partially indigenous ancestry of the northeast's settlers. (Many of Nuevo León's first settlers were in fact Tlaxcalan Indians from the Mexican heartland far to the south.) Nahua place names also dotted the landscape, and many of Nuevo Santander's early official documents were written in the Nahuatl language. Folk tales of hauntings and the devil taking human form, and shrines to local healers and saints, reflected both medieval Catholicism and Indian religiosity. Though records are scanty, many of the Coahuiltecans surely intermarried with the Hispanic settlers and became incorporated into their culture. Many of the natives' most favored liturgical symbols and plants also adorned church doors and architec-

tural details. Even the plazas of Nuevo Santander's towns may have their indigenous roots. Although we generally think of plazas as European, the large ceremonial squares of the Aztec, Maya, and other American peoples bear more resemblance to what came to be known as the "Spanish" plaza than did the irregular and dispersed spaces of medieval European cities. Nuevo Santander's colonists were not Indianized to the extent of their counterparts in New Mexico, who had lived alongside more numerous Pueblo and nomadic peoples since the early seventeenth century, but they were nonetheless a hybrid people.[6]

García and his family brought these traditions into American life in 1848, when their ranches and homes, just on the north side of the river, became a part of the United States with the signing of the Treaty of Guadalupe Hidalgo. Along with tens of thousands of others living in South Texas, New Mexico (which encompassed almost all of what is now Arizona), and California, the treaty granted American citizenship to those who chose to remain in what was now the United States. Or they could retain Mexican citizenship by moving to Mexico's reduced territory—for García, a simple crossing of an often-shallow river.

For most, this was no choice at all: whatever Mexico meant to them, it was not enough to make them leave the only homes they had ever known. Indeed, membership in a local or regional community—New Mexico, the northeast, a particular town or village—was as important to most residents of Mexico as was their Mexican citizenship. (In this respect, Mexico was not so different from its northern neighbor, despite the greater hold of U.S. nationalism over most Americans. Thirteen years after the signing of the Treaty of Guadalupe Hidalgo, for example, when Robert E. Lee vowed to fight for his nation, he meant Virginia.) The vast majority of people of Mexican descent in the American Southwest stayed put. Some, however, decided to move within several years. "They would rather lose everything," a Mexican official noted in 1849, "than belong to a government in which they had fewer guarantees and were treated with more scorn than the African race." Compelled by a sense of Mexican patriotism, and driven by the hostility, threats, and violence of incoming Anglos, hundreds of people from Texas, and perhaps several thousand from New Mexico, moved across the new border. The Mexican government did what it could to entice such relocations, providing a small grant to those patriots who moved, with a supplement for military men who might help form a bulwark against further U.S. encroachment. Those leaving Laredo, one of the few Nuevo Santander towns on the north side of the river, founded Nuevo Laredo on the opposite bank, and departing *nuevomexicanos* established three new towns near Chihuahua's border.[7]

García and his family left no record of the reasons for their decision to stay. The transformation of the Río Bravo del Norte into the international border of the Rio Grande may have made for a different map, but it didn't immediately bring changes to the community of ranches and towns that straddled the new border. Perhaps García simply intended to bide his time and see what life was like under a new flag. It is

even possible that he or his family members welcomed the arrival of U.S. rule: some leaders of Mexico's north acceded to the U.S. invasion, hoping that American armies would offer greater protection from Apaches and Comanches, and that incorporation into the U.S. market would bring greater prosperity than languishing on the edge of Mexico. Some Mexican Texans had joined the Texas Revolution in the previous decade, for similar reasons. Most of these figures ended up bitterly regretting their decision: Juan Seguín, for example, was repaid for his brave service in the armies of the Texas Revolution by being expelled from San Antonio by an Anglo

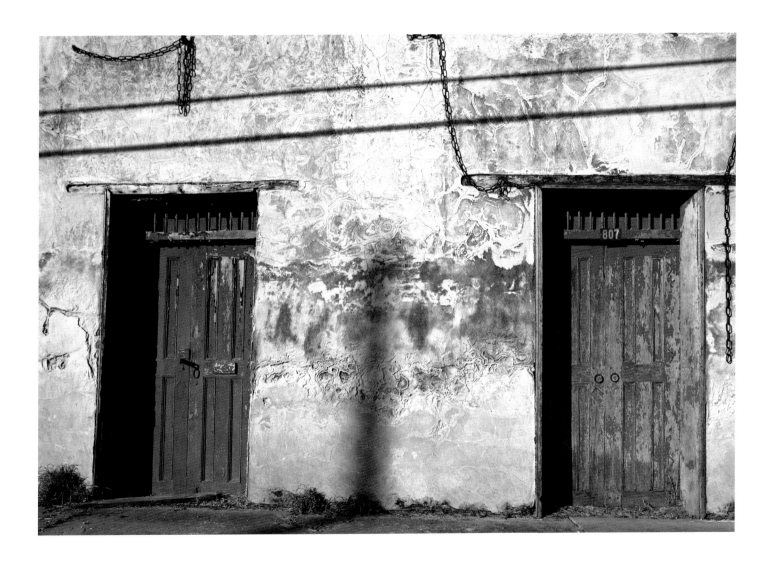

mob. But people like García could hope for the equality of citizenship and protection of property rights promised in the Treaty of Guadalupe Hidalgo.

One action taken by García and his circle suggests that whatever other considerations they had, they saw considerable opportunity in remaining where they were. In 1848, just a single week after the signing of the Treaty of Guadalupe Hidalgo, the town of Roma was formally established. The García family contracted with Anglo lawyer Edward R. Hord to lay out lots and sell them to Anglo-American newcomers. For some years the town site had been an important ferry landing, and the Garcías

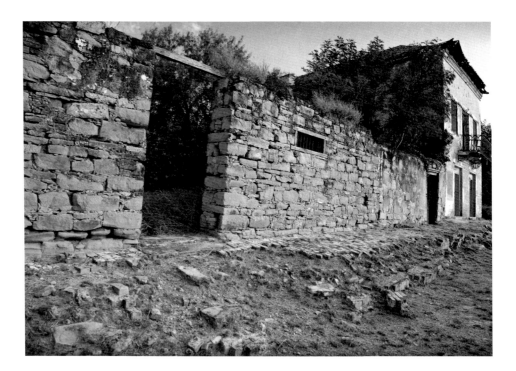

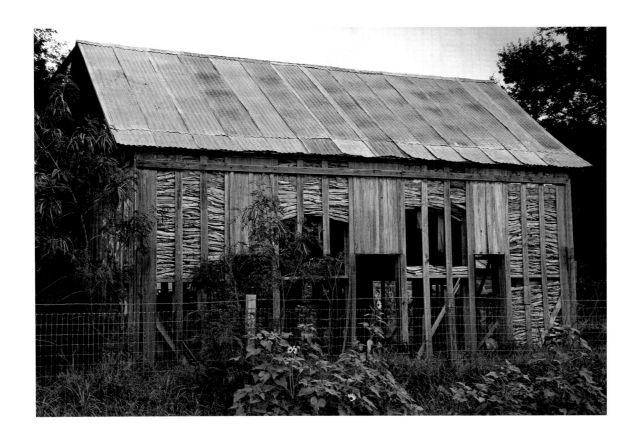

apparently hoped that founding an American border town would create new commercial opportunities. The town plan was itself an odd variation on Spanish urban principles. The grid of streets oriented around a main plaza would have been familiar to any Mexican, but the plaza was three times longer than its width, instead of the usual ratio of one and a half to one. This length lent it to use as a wide avenue for the commercial traffic coming and going from the river landing at its southern end as much as for the social life and foot traffic that typically dominated plazas. No lot was set aside for a church, another departure from standard Mexican practice.[8] The new town of Roma was from the beginning neither fully Mexican nor American.

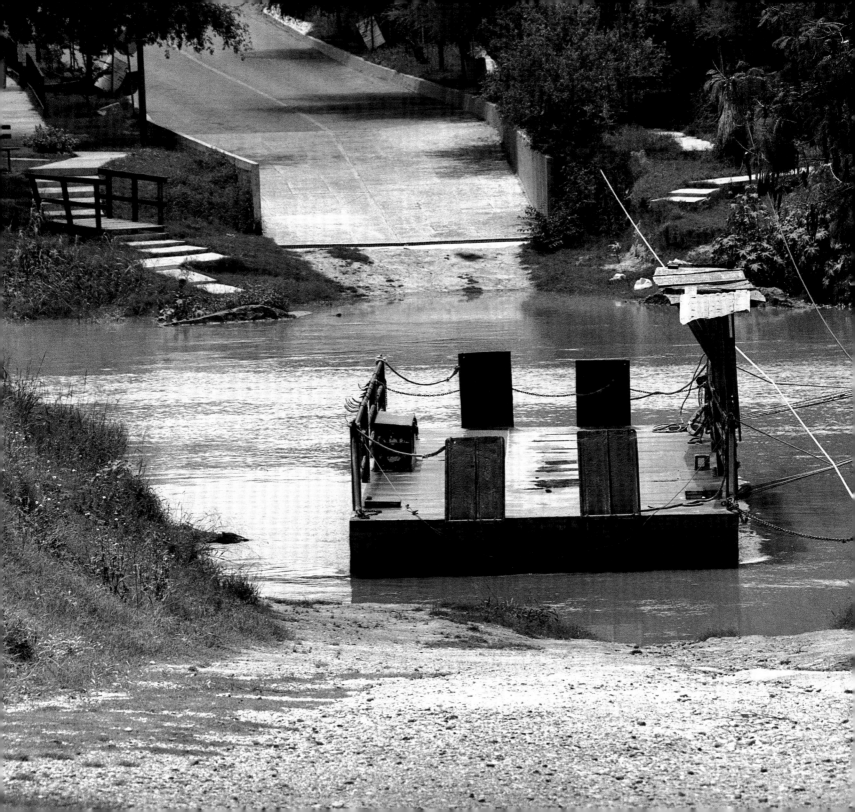

Charles Stillman

ON MAPS, THE CLEAN LINES OF BORDERS divide countries from one another, but anybody who lives on a border understands that they also bind countries together, allowing people and goods to cross from one nation to another. Even small and seemingly remote border towns thus often serve as funnels for enormous amounts of international commerce.

So it was with Roma from the beginning, as José María García Sáens foresaw when he arranged for the town's creation and commercial orientation. Not only did local trade continue in the region now bisected by the new international border, but the tariff policies of both Mexico and the United States created incentives for much greater commerce, some of it legal and much of it not. Like most countries at the time, the two nations' governments raised the bulk of their tax revenue from a long list of import duties. Merchants who avoided paying those duties could gain enormous profits, so smuggling immediately became a major feature of border life. Although Americans today think of the border as a place where illegal goods and people are brought into their country from Mexico, for most of the line's history their southern neighbor has been the recipient of this illicit commerce.

William Emory encountered vivid signs of this just a few years after the border was created. Impressed but puzzled by the extent of Roma's prosperity, he found an explanation one night. "When I went out to take my observations for the determination of the latitude and longitude of the place," he wrote, "I found that the mercury of the artificial horizon was very tremulous, notwithstanding the calmness of the

night. Not being able to overcome the difficulty, or ascertain its cause, I put up my instruments and returned to my quarters." Soon the answer to this mystery announced itself: "On the way I encountered a long train of mules, heavily laden, directed towards the Mexican side of the river. The motion of the animals caused the disturbance of the mercury, and their rich burden of contraband goods, intended for the Mexican market, explained the commercial prosperity of the town. As might reasonably be expected in any country where the duties on foreign goods amount almost to prohibition, smuggling ceases to be a crime, but is identified with the best

part of the population, and connects itself with the romance and legends of the frontier."[1]

Emory may have underestimated the extent of the lower border's legal commerce. Long before the age of NAFTA and the prophets of a global economy, visionary entrepreneurs saw enormous commercial opportunities in places far from the

centers of national power. One such person was Charles Stillman, who came to Matamoros in the 1820s as a young man. Drawing on his family's New England mercantile connections, he threw himself into a dizzying array of business enterprises in the newly independent nation of Mexico, running a general store, exporting Mexican agricultural products to New York, engaging in land speculation, acquiring mineral claims, and organizing a regional shipping company. More interested in turning a profit than in anything else, Stillman somehow managed to avoid getting caught up in the political tumult of the Texas Revolution and the

U.S.-Mexican War. The latter conflict was actually an enormous boon to him, as he secured lucrative contracts to move and supply American troops up and down the Rio Grande on steamboats, with Roma as the upstream point of reliable navigability. After the war, Stillman was quick to realize that the creation of a new international border offered him even greater prospects for commercial success, as he told his distant and puzzled Yankee family: "There's nothing down there but the Rio Grande. There's nothing across the Rio Grande but Matamoros. There is nothing in Matamoros but the gateway to all Mexico for cotton, hides, and gold."[2]

Charles Stillman's varied enterprises and their acceleration after the border's creation seemed to confirm the prophecies of William Emory and John Bartlett. So too did some of the consequences for Hispanic settlers, whom the border's surveyors expected to wither away in the face of superior Anglo drive and intelligence. Stillman certainly cooperated with Mexican and Mexican-American businessmen—many of his endeavors south of the border were in partnership with Mexican nationals, and some sources indicate that the García family consulted him in the establishment of Roma. But many of his gains came at the direct expense of people like García. In the immediate aftermath of Mexico's defeat, Stillman purchased enormous acreages north and northwest of Matamoros from distressed heirs whose claims to the property were dubious at best. He carved out the city he named Brownsville from some of this acreage—from tracts attached as common property of the city of Matamoros, which were inalienable by Mexican law—and turned a handsome profit by dividing and selling the town's lots. All of this was lucrative for Stillman, but infuriating to the heirs who chose not to sell and saw their patrimony stolen from underneath them. Led by a charismatic rancher named Juan Cortina, these families pursued an on-again off-again guerrilla war along the lower border

that lasted nearly three decades. At its height, these rebels forced open combat from Brownsville upstream more than a hundred miles nearly to Roma. They actually captured Brownsville in 1859 and forced the dispatch of the U.S. Army, which, under the command of a little-known colonel named Robert E. Lee, forced Cortina and his partisans across the river and into Mexico.[3]

All along the new border, the success of Anglo-American entrepreneurs like Stillman created enormous tensions between Anglos and Hispanics. "Flocks of Vampires came and scattered themselves in the settlements," proclaimed Juan

Cortina when he captured Brownsville. "Many of you have been robbed of your property, incarcerated, chased, murdered, and hunted like wild beasts, because your labor was fruitful, and because your industry excited the wild avarice which led them." Even in the young town of Roma, which avoided the conflict and outright violence downstream, the majority of town lot buyers and new merchants were recent Anglo arrivals from Galveston, New Orleans, and New York. Farther inland from the river, the enormous King and Kenedy ranches—founded by Stillman's shipping partners Mifflin Kenedy and Richard King, and in the case of Kenedy's ranch, from land sales by Stillman—grew exponentially, displacing hundreds of Hispanic ranching families and leaving scores of bodies in the chaparral. Farther west along the boundary things looked even worse for Mexican pioneers in their new country: vigilante violence drove Hispanic porters out of the shipping business in El Paso and expelled Mexican and Mexican-American miners from the rich gold fields of California. Within a generation, the wealthy Hispanic ranching elite of the Golden State found itself nearly dispossessed by fraud, violence, and economic desperation. Perhaps even José María García Sáens wondered if he could make a go of it in the United States.[4]

For other groups of Mexicans and Americans, however, the border was the source of greater hope. There were those who had much more to gain than mere profit by crossing the early border. The thirty percent of Texans who were enslaved understood this. Although most Americans thought of Mexico as a backward nation hampered by primitive Catholicism and burdened by the weight of its past, slaves had reason to see it in a different light: Mexico had abolished slavery in 1829, within a decade of gaining its independence, while slaveholders still dominated the highest offices in the United States. Human beings who were property north of the

Rio Grande belonged to nobody but themselves on the south side. "In Mexico you could be free," remembered one former slave decades later. "We would hear about [those who fled] and how they were going to be Mexicans. They brought up their children to speak only Mexican." Most of the slaves in Texas lived far from the border, in the humid cotton-growing regions of east and central Texas, but many were willing and able to make journeys of hundreds of miles to reach freedom. Some came from as far away as Louisiana and Arkansas. Those who fled from bondage risked their lives, but the promise of freedom offered by the border was real enough to make flight much more common in Texas than in the South as a whole. Texas slave masters understood this threat; a group complained that "something must be done for the protection of slave property in this state. Negroes are running off daily. Let the frontiers of slavery begin to recede and when or where the wave of recession may be arrested God only knows." Escaped slaves found refuge in Mexico, prompting occasional slave-raiding expeditions by Texas authorities, or in South Texas itself, where some settled down and married into local families.[5]

Fleeing north held a similar promise for some Mexicans. Servants exploited or held in debt peonage on Nuevo León's northern haciendas found refuge by crossing the border. So while some borderlanders headed south to preserve their Mexican citizenship, others headed north to escape lifelong servitude. This exodus continued for several decades; a Mexican government commission conservatively estimated that more than five thousand people had fled Nuevo León and Coahuila for Texas in the first fifteen years of the border's existence. Much as fugitives undermined slavery in South Texas, the peasants of Mexico's northeast edge forced hacienda owners to abandon debt peonage and offer better wages and working conditions. "Nobody changes nationalities to assume a worse condition," wrote a Mexican senator of these

migrants, "and it is very dangerous to see just beyond the arbitrary line prosperity and wealth, and on this side destitution and poverty." The slaves and laborers crossing from both sides never achieved the fame or wealth of a Charles Stillman, but they made the border a fixture of popular hope in North America from its beginning.[6]

The decisive and best-known chapters of the U.S. Civil War played themselves out hundreds of miles from the border. It was in Virginia, Tennessee, Mississippi, and Pennsylvania that the critical battles were won and lost, in Washington and Rich-

mond that leaders made pivotal decisions, and from the eastern states that most of the soldiers came. But in a sense the conflict was about the borderlands. It was the dispute over whether slavery should be extended into the West that proved impossible to settle without resort to violence. Ralph Waldo Emerson, among others, had foreseen that the seizure of the Mexican north would fatally divide the nation. "The United States will conquer Mexico," he prophesied in 1846, "but it will be as the man swallows the arsenic which brings him down in turn. Mexico will poison us."[7]

Once the war came, it transformed Roma and the lower border, in ways as tangible as new buildings and towns and as elusive as how borderlanders thought of themselves. Charles Stillman could see this in the flood of cotton crossing the Rio Grande. Cotton was called "King" for good reason: the key raw ingredient for the textile mills of Europe and New England, it was both the slave South's most profitable crop and the nation's leading export. Much of this enormous international trade soon pivoted from New Orleans and the Atlantic coast, blockaded by the Union, to the lower border, where Stillman and his partners King and Kenedy played leading roles in delivering it to the world market via Matamoros and the new coastal city of Bagdad. Teamsters, many hired by Stillman, hauled the cotton overland from the principal commercial centers of Texas to the Rio Grande, where it was ferried across by Stillman's steamboats and taken to warehouses in Matamoros and Bagdad, and then carried by ships of many nations (including the Union) to the rest of the world. A young teenager recalled that the South Texas ranch country "became a broad thoroughfare along which continuously moved two vast, unending trains of wagons; the one outward bound with cotton, the other homeward bound with merchandise and army supplies." Many of the Confederacy's munitions came north through Mexico, as in the early months of the war when a Monterrey partner of Stillman's was asked

to deliver five hundred tons of lead and two hundred thousand pounds of powder to Roma.[8]

Thirteen years after its creation, the border was thus for several years a critical node in the global system that linked factory workers in Massachusetts and England, bankers in New York and London, merchants in Monterrey, Galveston, and New Orleans, Confederate and Union armies in Virginia and Pennsylvania, slaves in the cotton fields of the South, and consumers of textiles all across the world. By some estimates Matamoros became the world's third most active port during the war, prompting renowned commercial firms like Lloyd's of London to open offices there. This was a boon to towns like Roma, which became an even more important border crossing when the Union invaded the mouth of the Rio Grande in 1863 and thereby closed the lower stretches of the river to the cotton trade. Roma secured its position as an important commercial center, with numerous merchants purchasing town lots and opening stores to take advantage of the flush times. José María García's commercial expectations had been wildly exceeded.[9]

War meant more than commercial prosperity. It also led borderlanders to decide what living in the United States meant to them. The nation that had forcibly annexed them barely more than a decade before was now split into two warring camps. Many Hispanics in places like Roma saw no reason to choose sides, and like Charles Stillman they simply went about their business, happy to take advantage of whatever new possibilities the conflict opened up. Some, though, thought that there was more at stake than a dollar or a peso. Although no Hispanic delegates attended the Texas secession convention, most of the Hispanic elite of South Texas sided with the Confederacy. In Starr County they helped to send Roma merchant Noah Cox and Rio Grande City lawyer Edward Hord (who had surveyed Roma for Jesús María García thirteen

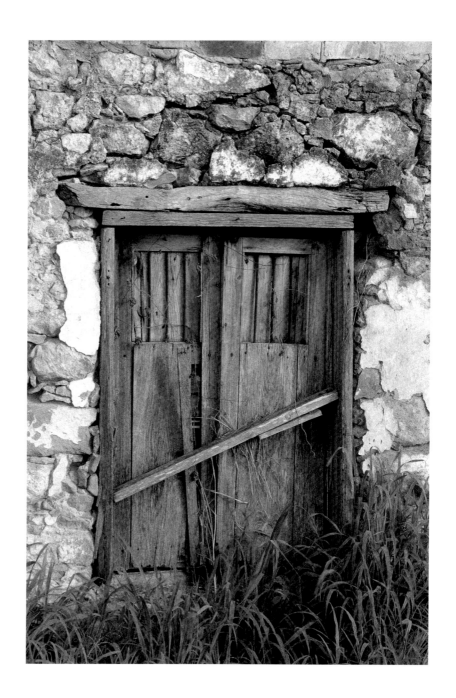

years earlier) to the convention. Upriver, Confederates were led by Judge Ysidro Vela in Zapata County and Santos Benavides in Laredo. Cooperating with local Anglo leaders, almost all of whom sided with the Confederacy, these leaders used fraud and the threat of violence in the 1861 referendum on secession, limiting pro-union votes to a grand total of two in Starr County.[10]

The Confederacy's emphasis on states' rights and the hierarchical and genteel aspects of Southern culture appealed to Hispanics like Benavides, who had used their own positions of power to fight for regional autonomy against centralizing Mexican governments before 1848. Other border Hispanics, however, passionately believed that the Union reflected their own values of independence and equality. The few years since American conquest had convinced them that the United States embodied values worth fighting for. A day before the surrender of Fort Sumter, some forty armed rancheros not too far to the north of Roma declared themselves in rebellion against the Confederacy and proclaimed their loyalty to "Old Abe, the rail splitter." Many were massacred by Hispanic Confederates a few days later.[11]

For the next four years, Hispanic Unionists and Confederates fought one another along the Rio Grande. Charles Stillman's implacable enemy Juan Cortina was a major part of this, running guns to Union partisans in Texas and attempting to strangle the Confederacy's cotton trade. (Even Cortina, so embittered by the dispossession brought to his family and people, spoke highly of American ideals, citing the Declaration of Independence and the Constitution to condemn Stillman and others for violating their own avowed principles.) The river crossings at Roma and Rio Grande City were important enough, and fear of Unionist sentiment high enough, that Confederate commanders kept as many as five hundred soldiers stationed in Starr County in the early years of the war.[12] When the Union army landed

in force near Brownsville in late 1863, the Confederate general in charge of South Texas forces was given orders to retreat upriver to Roma, in recognition of the town's significance as a cotton port. But he refused to do so, pleading with his superiors that "men on both sides of the Rio Grande will soon be in the saddle, and under the direction of the United States officers, will destroy this country. . . . To attempt to hold Roma with one company is too much risk."[13] Instead, he headed inland to a prominent ranch, later explaining that upriver "the whole country will be against me." Although the vast territory, harsh climate, and persistence of Confederate units prevented the Union from conquering South Texas, a U.S. detachment that reached as far upriver as Roma was able to enlist several hundred men into cavalry units mustered out of Starr County.[14] The last organized battle of the Civil War was fought at Palmito Ranch outside Brownsville in May 1865, a month after Lee's surrender at Appomattox. At least a few copies of newspapers reporting both the South's capitulation and Lincoln's assassination had reached the Confederate forces, but their commander insisted on pressing the engagement, perhaps to save large quantities of contraband cotton from seizure by their Union foes.[15]

The end of the war left Charles Stillman in a good position to appreciate how much it had bound up the border with the larger nation. He faced some complications— he had after all done the vanquished Confederacy a great service, which created some resentment in the North—but the war left him one of the world's richest men. In 1866 he moved back to New York for good and reinvested the bulk of his profits in its National City Bank, which his son James later made the world's first billion-dollar corporation.[16] The millions of Americans who carry Citi credit cards today may not know anything about places like Roma, but Citigroup's financial empire

would not have been possible without the countless bales of cotton that came through those border towns. Stillman's Mexican counterparts embarked on a similar trajectory, using the enormous capital accrued from the sale of Confederate cotton to make Monterrey the seat of Mexican industry. At least one of these merchants used this capital to found Cervecería Cuauhtémoc, Mexico's first modern corporate brewery. The tens of millions of Americans and Mexicans who enjoy Carta Blanca, Tecate, Bohemia, and Indio beer thus owe some of their drinking pleasure to the Civil War's cotton trade.[17]

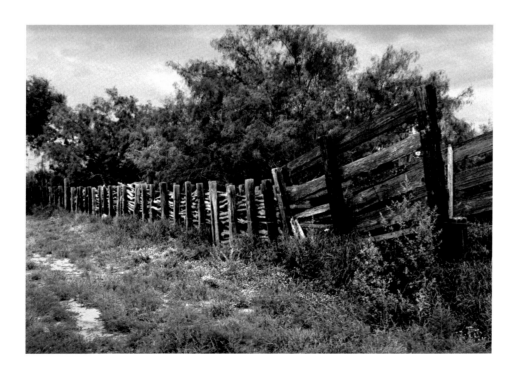

North of the border, Stillman's associates Mifflin Kenedy and Richard King fared similarly well, using the capital they had amassed from the trade to expand their ranches even further. In the next decade, they were key players in the enormous cattle drives north from Texas to the railheads of the Plains. Because they relied on Hispanic workers and ranching practices, they thus helped introduce something of the border into mainstream American culture. To this day, when Americans speak of cowboys and ranches, they use Spanish words or Anglicized versions of them: bronco, buckaroo, burro, mesa, canyon, rodeo, corral, lariat, lasso, chaps, and even ten-gallon hat. And in the 1860s, when the residents of towns like Roma spoke of the United States, they knew that it was not merely a distant place that sent men speaking a different language to take over much of their ancestral land, but also a nation whose survival they had fought for.[18]

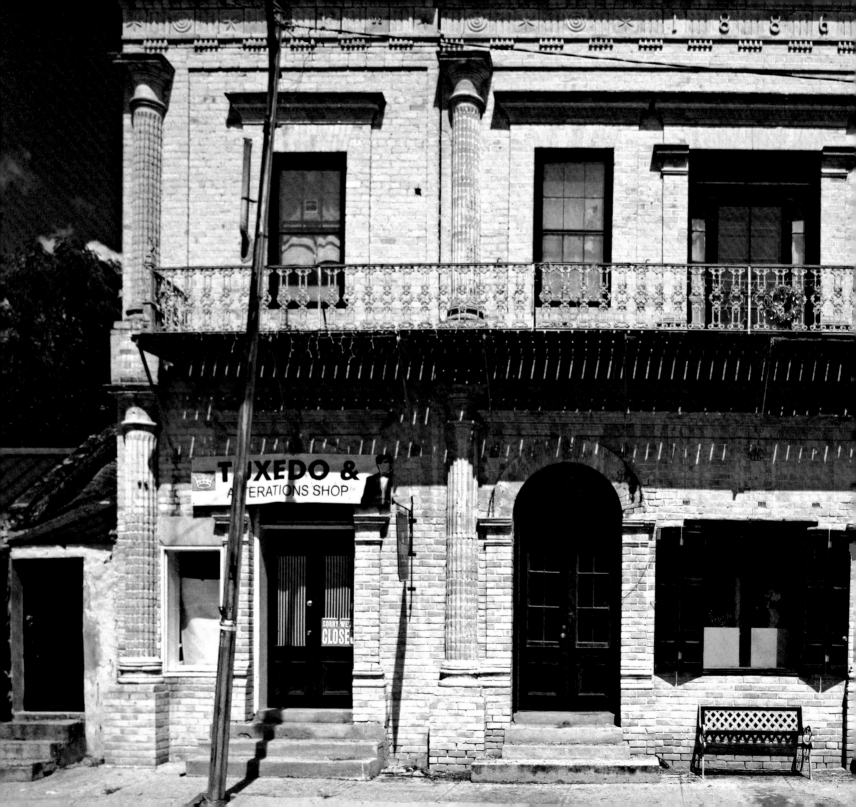

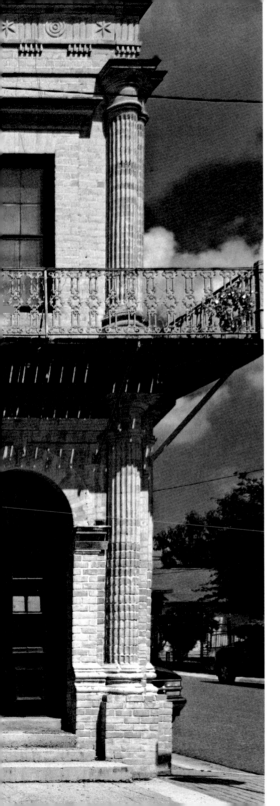

Heinrich Portscheller

MEXICO EXPERIENCED ITS OWN CIVIL WAR in the 1860s, with nationalist forces loyal to the elected president Benito Juárez struggling against a French-backed imperial government that enjoyed the support of the Catholic Church and most of the nation's wealthiest landowners. The two conflicts merged on the lower border, with an informal alliance between Unionists and followers of Juárez arrayed against Confederates and supporters of the French imperial forces. While Juan Cortina, a supporter of the Unionist cause in South Texas, fought for Juárez for most of the war, the Laredo Confederate Santos Benavides hoped for an imperial victory. A few years after Robert E. Lee's surrender at Appomattox, Juárez's government finally won the protracted war. The victory bolstered Mexican nationalism; Cinco de Mayo commemorates the unexpected defeat of a much larger French army marching toward Mexico City. The war's conclusion did spell the end of the border cotton boom, but it also brought greater stability to Roma and the other towns on the banks of the Rio Grande.

It was near the close of these intersecting civil wars that Heinrich Portscheller first came to Roma. Born in 1840 in Germany to a family of building tradesmen, at age twenty-five he headed to Mexico with a friend. Arriving at the port of Veracruz on the Gulf Coast, he soon found himself compelled to join the imperial army. In 1866 he deserted and crossed the river into Texas, where he found work as a mason at the army fort in Rio Grande City. Because of his personal craftsmanship and ability to design and construct homes, commercial buildings, and cemetery vaults,

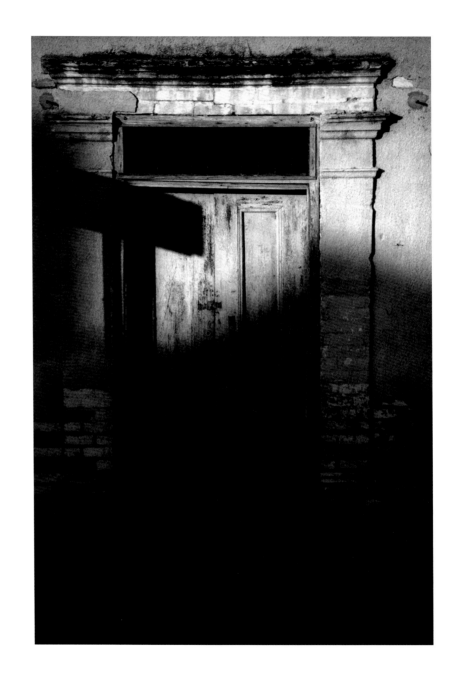

Portscheller soon found himself in high demand on both sides of the border, particularly in Roma, Rio Grande City, Mier, and the surrounding ranches and settlements. He made Roma his home in the early 1880s, and by the time of his death in 1915 he left a series of distinctive structures that managed to blend northern Mexican building traditions with the needs and aesthetic of a more commercial modern age.[1]

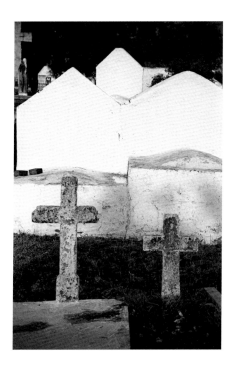

The key to Portscheller's success was to integrate himself, professionally and personally, into the borderlands community. He lived and worked on both sides of the border, working as far south as Monterrey. While living in Mier, he married a woman named Leonarda Campos, and shortly afterward the couple moved to Roma, where they raised four children. Spanish was thus the language for both Portscheller's business and family life, just as the peso was the dominant currency on both sides of the border. At some point he became known as "Enrique." Other outsiders who remained in Roma followed a similar path. By the end of the century, the twenty-two people in Roma with non-Hispanic last names included two Anglo widowers of Hispanic women, and seventeen descendants of Anglo-Mexican marriages.[2]

Enrique Portscheller's popularity was due to his own skill as an architect and builder, but at the same time his work drew upon local traditions of brick making. He hired local craftsmen to perform much of the complicated work of digging clay, molding it, and firing it at the right temperature for the right length of time. (In the firing process, experience, intuition, and mesquite logs served in place of the mechanized gas-burning kilns and thermometers that eventually industrialized brick production.) Many of the key craftsmen who worked for Portscheller or for themselves learned their trade from their fathers and passed it along to their

sons, and they all were able to easily cross what remained an uncontroversially porous border. As one member of a brick-making family remarked decades later, "In those days there were no differences. There was a boat here for you to come and go. There were no passports here. There were no 'wetbacks' here. There was nothing here. You lived over there and you came back here and that's all there was to it."[3]

Thus Portscheller represented not the aping of outside knowledge, but rather its comfortable and creative fusion with local culture. This ran contrary to the larger pattern in the United States, for Roma was exceptional in the ability of its Hispanic elite to bring its regional cultural traditions into modern American commercial life. In the time of Portscheller's career, the Anglo political and economic elite of the borderlands despised Hispanic building practices. Adobe and irregular handmade "Mexican brick" reflected the supposed backwardness and decline of Mexican-descended people. "Uninviting mud walls that form rude hovels," sniffed one traveler about structures made from such materials.[4] Anglo journalists and travel writers, following the lead of William Emory, routinely juxtaposed descriptions of dilapidated adobe and Mexican brick structures with observations about the degeneracy of Mexicans and the triumph of Anglo civilization. When Anglos assumed dominance in Los Angeles, California—as they were being bought out in Roma—one observer lauded the physical changes they brought to the formerly Mexican town. When Mexicans controlled Los Angeles, he claimed, there were only "crooked, ungraded, unpaved streets; low, lean, rickety, adobe houses, with flat asphaltum roofs, and here and there an indolent native, hugging the inside of a blanket, or burying his head in a gigantic watermelon." "But a wonderful change has come over the spirit of its dream," he continued, "and Los Angeles is at present . . . an American city.

Adobes have given way to elegant and substantial dwellings and stores . . . industry and enterprise have now usurped the place of indolence and unproductiveness." Another tourist in Los Angeles was more blunt: just as crumbling adobes gave way to modern brick structures, so too did Hispanics have "to give away to the stronger white man."[5]

When they didn't, Anglos would help things along: In 1880, for example, the archbishop of Santa Fe transformed the adobe Iglesia Nuestra Señora de Guadalupe into an oddly gothic building to be known as Our Lady of Guadalupe Church. Soon

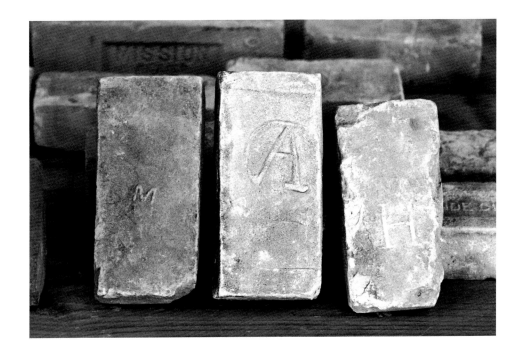

the rest of the churches in his diocese featured stucco overlays on the old adobe, often painted and marked to look as much as possible like European stone churches.[6] In new construction for secular buildings, machine-made brick took on a set of meanings for western Anglos that it is difficult for modern observers to appreciate. "Brick stood for the Anglo future," one historian tells us. "Brick was stolid, solid, and firm. Brick—at least fired brick—could be counted on to be of standard size, regularized and identical brick after brick after brick. . . . Brick took

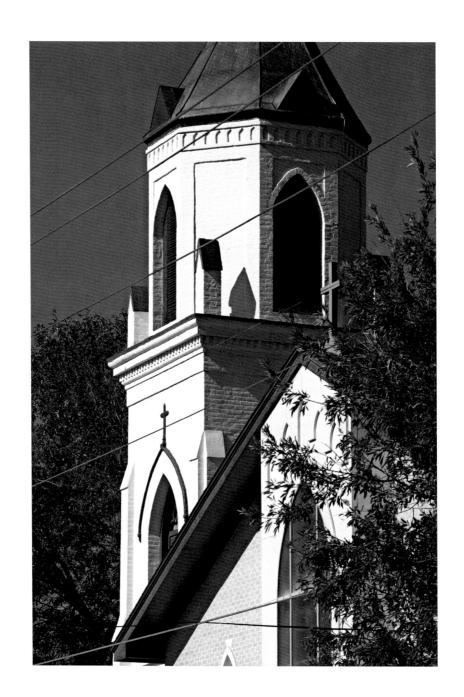

up . . . exactly at the moment of racial turnover."[7] Little wonder that the property deeds in new Anglo settlements in South Texas often actually required brick construction.[8]

Roma's physical appearance defied this pattern because Roma defied it. While most immigrants to the United States in this period found themselves pressed to conform to Anglo-Saxon culture, particularly its insistence on Protestantism and the English language, Portscheller made his home in a place where Anglo power

was on the ebb. By the end of the Civil War cotton boom, it looked as though Roma would follow the pattern of downriver and most of the rest of the borderlands, in which incoming Anglo merchants quickly took control of most land and key economic and political positions. But in the mid-1860s, a group of Roma's leading Hispanic citizens organized themselves into what they called *la masa de heredores*— the group of heirs. These families, which included the descendants and cousins of José María García Sáens, pooled their resources and knowledge to buy out the Anglo-American newcomers. To the south, desperate Hispanic ranchers watched Charles Stillman's towns and the voracious King Ranch devour their lands. Upriver, Mexican-descent settlers lost ground even in El Paso, excluded from its circles of power. Far to the west, the city once known as El Pueblo de Nuestra Señora La Reina de Los Angeles de Porciúncula was now called L.A., one of the most heavily white and native-born cities in the nation, with Mexicans confined to a small and decrepit portion of the central city.[9] But in Roma it was Hispanics who gained ground.

How the masa succeeded is unclear—only vague references to it survive—but that it did is undeniable. As Portscheller's career went on, the people who came to the town's dozen or more mercantile stores for daily necessities, ranching and agricultural supplies, and special items such as wedding dresses and china were more and more likely to do business with Hispanics. Portscheller's own best clients in Roma—Antonio Sáenz, Manuel Guerra, Nestor Sáenz, Pablo Ramírez, and Rafael García Ramírez—were key members of the masa. By the end of the nine-teenth century, barely twenty people with non-Hispanic surnames lived in the town, whose elected officials and leading economic powers were all Hispanic.[10]

Heinrich Portscheller was not the only outsider to ultimately make a home for himself in this cohesive and resilient Hispanic community. Like the architect, most of Roma's priests were European émigrés, and like him, they were witness to and participants in the town's distinctive trajectory after the Civil War. Roma's best-known priest was Father Yves Keralum. Keralum, himself a journeyman architect and carpenter, first came to Roma five years after its founding, the same year that William Emory passed through. A member of the Oblate Order of Mary Immaculate, based in

France, this Belgian priest brought organized religion to the town and surrounding ranches, performing his first baptism in 1853. Severe funding shortages and demands on his time kept the Oblates from securing a permanent presence in the town until shortly after the Civil War, when they returned to use a small church there to minister to Roma and scores of surrounding ranches.

In material terms, the lives of these early missionaries were much more difficult than Portscheller's, as difficult as those of the common people to whose spiritual needs they committed themselves. Two small cottages, one used as a church and the other as the priests' residence, constituted their only physical plant. The church hardly had the requisite material possessions for the basic Catholic rituals of mass, weddings, and baptisms. The sanctuary bordered on structural unsoundness by the 1870s. Moreover, the extended family networks of Roma and its environs often proved inscrutable to the mainly French and Belgian priests sent to administer them. Poverty, occasional theft, and an outright refusal to sponsor the building of chapels deeply frustrated the Oblate fathers. Roma's founders were more interested in commerce than in church attendance, so much so that they made no provision for a church when drawing up the town plan. The masa was little different, with its members willing to hire Portscheller but often declining increasingly desperate pleas from the Oblates for church repair funds.[11]

Keralum and his successors were in an excellent position to appreciate just how isolated the border region remained from the rest of the United States. Organizationally, the Oblates grouped their Roma mission with churches in nearby Rio Grande City, Brownsville, and Agualeguas, Mexico, into the twentieth century, reflecting their view that these places all had more in common with one another than the Texas towns had with other Oblate missions in the United States. Starr

County, they knew, was deeply tied to Mexico: it was not until the 1880s, when Portscheller moved to Roma, that U.S.-born residents outnumbered those born in Mexico, and even the 1910 census, the last before Portscheller's death, found that more than a quarter of the county's population was born in Mexico and that nearly half of those born on the U.S. side had at least one parent from Mexico.[12] The movement of population to the north of the river was technically an international migration, but in a more profound sense it was a local and regional one, the continuation of ordinary life in the boundaries of José de Escandón's Nuevo

Santander. Almost all of those moving to South Texas from Mexico were from the adjacent states of Nuevo León and Tamaulipas, and three quarters of the Tamaulipans came from border towns, including the nearby Mier and Reynosa.[13]

The Oblates found benefits in the strong ties between their border missions and nearby Mexican towns. A priest visiting Roma in the 1880s reported to his superiors with relief that the residents' "piety has not yet been contaminated and the reason is that in this part of our Mission there has been no mixing with the Americans, who, when they establish themselves in a place, give us reason to consider it as lost. The greater part of them are adventurers, without Faith or Law. They are mostly protestants. Our Mission is still preserved from this plague, but we are surrounded on all sides by this element, which will finish eventually, by spreading all over it and corrupting the religious spirit of our people." This spreading and "corruption" never happened. In 1909, an archbishop noted to the Oblate priests "the necessity of acquiring a good knowledge of the Spanish language in order to obtain the desirable success in this ministry," adding that it wouldn't hurt to learn English, either.[14]

Like Portscheller, the Oblate fathers adapted themselves to local culture. Father Keralum and his compatriots learned to ride horses, taking mass and the other rituals to the region's widely dispersed ranchers. They rode so far and wide that they came to be known as "the cavalry of the cross." Keralum, eventually known as "Padre Pedrito," continued this often-grueling work despite poor health and failing eyesight. In late 1872 he headed out of Roma to surrounding ranches on horseback. Hitting fierce weather, he became lost in the chaparral. Ten years later, cowboys searching for lost cattle found his cross-adorned skeleton next to the remnants of his saddlebags in a mesquite thicket.[15] Roma churchgoers annually reenact the

ill-fated ride, with many locals calling for Keralum to be considered for sainthood. All across South Texas the priests still pass out a prayer card in his honor, with a drawing of him, on horseback, next to a large cross with his crucified savior. "My Lord God," they intone,

I have no idea where I am going.
I do not see the road ahead of me.
I cannot know for certain where it will end . . .

Jovita González

JOVITA GONZÁLEZ SPENT MUCH OF HER childhood among Heinrich Portscheller's graceful buildings, and her parents and grandparents surely attended some of the masses conducted by Yves Keralum and his fellow priests. Like most of the region's residents at the dawn of the twentieth century, González descended from deeply rooted ranching families. Her ancestors came with José de Escandón to Nuevo Santander; one even served as surveyor. Most crossed over to the Mexican side after the Treaty of Guadalupe Hidalgo, but after the Civil War her grandfather returned to the north side of the river and purchased the Starr County ranchlands that had once belonged to the family. Jovita was born in Roma in 1904 and spent much of her childhood on the family's nearby ranch. Though she had to leave in order to do so, she became Roma's most distinguished native child and helped usher in a new role for the border in American life.[1]

González's family members may have owned their own land, but they did not possess the wealth and prominence of the plaza merchants and large ranchers who employed Portscheller. Nevertheless, they did have aspirations for their children. "As a poor man," González later remembered, "my father felt that the only heritage he could leave his children was an education." He was particularly insistent that the traditional Spanish-language training he had received was not enough for people who wanted to be successful in the United States. And so the family left Roma for the much larger and more cosmopolitan San Antonio when she was a young child, although González would always maintain ties to Roma and its environs, and spent

the rest of her life writing about them. Years later, her farewell visit to her great-grandmother, the family matriarch, across the river in Mier was still seared into her consciousness. "Your mother tells me you are moving to live in San Antonio," the old woman said from her large bed as she beckoned her great-grandchildren close. "Did you know that land at one time belonged to us? But now the people living there don't like us. They say we don't belong there and must move away. Perhaps they will tell you to go to Mexico where you belong. Don't listen to them. Texas is ours. Texas is our home. Always remember these words: Texas is ours, Texas is our home."[2]

Her father's hopes for her education were fulfilled and even exceeded: she returned to Starr County as a schoolteacher in Rio Grande City for two years after high school, then worked as a teacher in San Antonio while attending a Catholic college there, became one of the few Mexican Americans to hold an advanced degree when she received a master's in history from the University of Texas in Austin, and by the 1930s was a national expert on Mexican-American life. She became president of the prestigious Texas Folklore Society, published numerous articles on border life, turned to teaching English and Spanish in Del Rio and Corpus Christi after her marriage in 1935, supported local civil rights initiatives, and left two novels published posthumously in the 1990s that cemented her reputation as a Hispanic cultural pioneer.

The history and culture of the people who settled places like Roma were the focus of González's extensive writings. By collecting the folk tales of the South Texas borderlands and describing the challenges that her people faced within American society, she tried to communicate the richness of this culture and its creators to both Anglos and Hispanics. Unlike some Hispanics who described themselves as

"Spanish" in an effort to avoid the stigma of Mexican-ness, González unabashedly captured the mestizo and Indian ancestry and influences on borderlanders and their culture. Although she occasionally discussed the exploits of famous men like José de Escandón and Juan Cortina, the protagonists and heroes of her work were the ordinary people who made it through life, occasionally beating long odds and often ending up with a smile on their faces. Their stories helped them to understand their world, offering answers as to how plants and animals acquired their names, why some people mysteriously fell ill and died, how marriages survived conflict, and how

some people scrupulously honored the demands of their religion while others despised and taunted priests.[3]

Social conflict, including tensions with Anglos and the difficulty of holding on to the land, was also a theme in her work. In one story, for example, Antonio Traga-Balas ("bullet-swallower") earned his moniker by miraculously surviving a point-blank shooting by Texas Rangers while crossing the river near Roma with smuggled goods. Many of these stories captured a sense of ambivalence, or even hostility, toward the United States. Traveling musician and cracker-barrel philosopher Tío Pancho Mal ("Bad Uncle Pancho"), who made frequent appearances in her publications, insisted that his six sons cross into Mexico to avoid being drafted into the army during World War I, keeping a straight face as he told American authorities who detained them, "We are sorry for the King that was killed and if you think it fitting and proper we can even write a letter of condolence to his widow." More than one story featured a ranchero patriarch clinging to his Mexican identity, forbidding his children to speak English and in one case crossing the Rio Grande each time a child was born to ensure that the little one would be born "in the land of his fathers."[4]

On the other hand, the native daughter of Roma had too much integrity to celebrate her own culture uncritically. As often as she returned to Roma and Starr County on family visits and research trips, González never again lived there after her brief stint as a schoolteacher in Rio Grande City in the early 1920s. In part this may have been because of her husband, Edmundo Mireles, whose work as a high school principal took them to Del Rio and then Corpus Christi. But her dislike for aspects of life in Roma may have played a role as well. Some of this was a matter of the restrictive roles allowed to women in northern Mexican society; her master's

thesis, for example, made it clear how exceptional her parents were in sacrificing so much for a daughter's education. It also predicted that gender roles would become more permissive as the small Mexican-American middle class grew in numbers and influence—which it did, but much more so in San Antonio and Corpus Christi than in anywhere near Roma. By the time González left her native town, a few of the leading families of Starr County, particularly Heinrich Portscheller's old clients the Guerras, had extended their economic influence into a political machine that made virtually all major political and economic decisions. Like some large southern plantations, the Guerras even had their own currency, redeemable for goods only at their store. "All the landowners in Starr County," she wrote of machine boss Manuel Guerra, "were a branch of his family or were related through marriage." In some ways these elite families were cosmopolitan and worldly: their children often went to college in Austin and Monterrey, and even Cambridge and New Haven, and more than a few married well-off Anglos. But their control of the county and strong favoritism to family members could make González's hometown a stifling place for an ambitious child from a modest family. She went so far as to call it "feudal."[5]

Patronage jobs have always been the lifeblood of such machines (whether in Chicago, Mexico City, or anywhere else), and in a place as poor as Starr County, public sector jobs were some of the best around. González was particularly angered by how the machine used the school system as a means of perpetuating itself rather than for bettering the lives of Mexican Americans. "When a group of boys and girls belonging to the privileged class, that is the landowners, reached the age, not the education, required of public school teachers they applied for a second grade certificate," she observed. "The questions with the answers were handed out by the examiner, who in exchange for this favor received a certain percentage of the

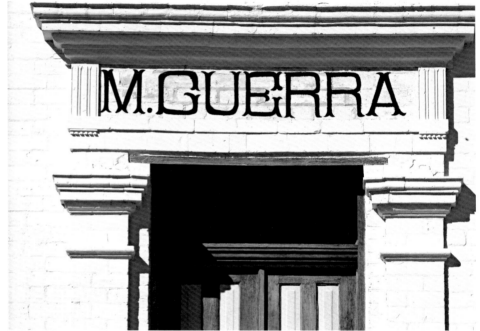

teachers' salary. The distribution of teaching certificates among the elect became a political issue and a means of controlling votes. The tax-payer who assured the political boss the greatest number of votes was sure of getting certificates for all his sons and daughters." No wonder Roma's lone secondary school was named Manuel Guerra High School.[6]

If Roma had its faults, then González came to believe that it was also true that the Anglo world had its virtues. Some of her stories' characters, like the scholar who

captured them, gratefully left the borderlands in search of an education at Anglo universities, institutions that served a larger end than did Starr County's patronage-ridden schools. Some Hispanic women in her two novels married attractive, respectful, and loving Anglo men, often against their parents' wishes. While her writings captured resistance to Anglo domination, they also featured people who admired American egalitarianism and contrasted it favorably with the more deferential and hierarchical culture of Mexico. She portrayed the peons of elite ranching families as exploited indentured servants who welcomed the opportunity to sell their labor in the wider market brought by U.S. conquest.[7] One particularly striking character in an unpublished novel was a sensitive artist, portrayed in such effeminate terms as to suggest homosexuality; he finds much more understanding in the Anglo art world than from his own sternly patriarchal family. In her most autobiographical story—like her novels, never published while she was alive—González imagined that her study became the site of a conversation between Sor Juana Inés de la Cruz and Anne Bradstreet, the two great women poets of Latin America and British North America in the seventeenth century. At first the two snipe at each other, exchanging the accusations of popery, piracy, and heresy that characterized relations between their cultures. But soon enough they realize how much they have in common—as poets, as residents of the colonial New World, as women, and even as designees of the honorific title "the tenth muse." Their exchange closes with an agreement to see each other again. The imagined conversation captured the heart of González's career—bringing Anglo and Mexican cultures into respectful discussion with each other.[8]

González began her career at a time when Americans simultaneously continued to treat Hispanics with enormous hostility and showed a growing interest in their

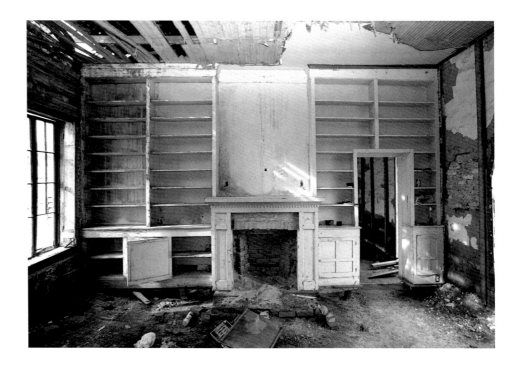

culture. Anglo Texas didn't present as monolithic a facade to González as it did to African Americans—she did get to attend the University of Texas, after all, with perhaps several dozen other Hispanic students from South Texas. But outside of a few border enclaves like Roma, the Texan Hispanic population, still by far the largest of any state, endured the indignities and humiliations of denial of service at restaurants ("No dogs or Mexicans allowed"), exclusion from public facilities like swimming pools and libraries, removal from jury pools and voting rolls, confinement to second-rate and segregated schools, residential segregation by deed restrictions

and common practice, and routine condescension and discrimination in job hiring and admission into higher education. Most Anglos knew nothing of the complexity and ingenuity of Jovita González's culture; if they knew anything about the history of Mexican Americans, it was that they were the butchers of the Alamo.

In the United States as a whole at the time of González's birth, people of Mexican descent were still rare curiosities; in the rest of the Southwest, they faced similar conditions as in Texas. González's native town became even more exceptional in the early twentieth century as one of the very few places where Hispanics were a majority, occupying positions of economic and political leadership and living their daily lives free of Anglo scorn. Only in the towns of northern New Mexico did Hispanics enjoy the numerical dominance and social standing that they did in Starr County and Zapata immediately upriver. Even downriver, at the southern tip of Texas, Anglo farmers flooded in after the completion of a railroad link in 1905 that transformed society, stripping most Hispanics of their land and inaugurating a horrific set of killings that claimed hundreds if not thousands of lives ten years later, as González attended high school in San Antonio.[9]

Culturally, however, major changes were afoot when González came of age. Even at the height of anti-Mexican racism, Americans slowly grew more and more fascinated by aspects of Hispanic and borderlands culture. Mexican food was an important and early element of this new appreciation. One of the Texas Rangers who came down to the border from San Antonio to fight Juan Cortina was so fond of chile con carne that several decades later he laid plans for a factory to make and can it on an industrial scale for sale to the army. His death in 1884 derailed the project, but nine years later the throngs attending the World's Columbian Exposition in Chicago could eat at a replica of a San Antonio chile stand. The same year in New Braunfels, Texas,

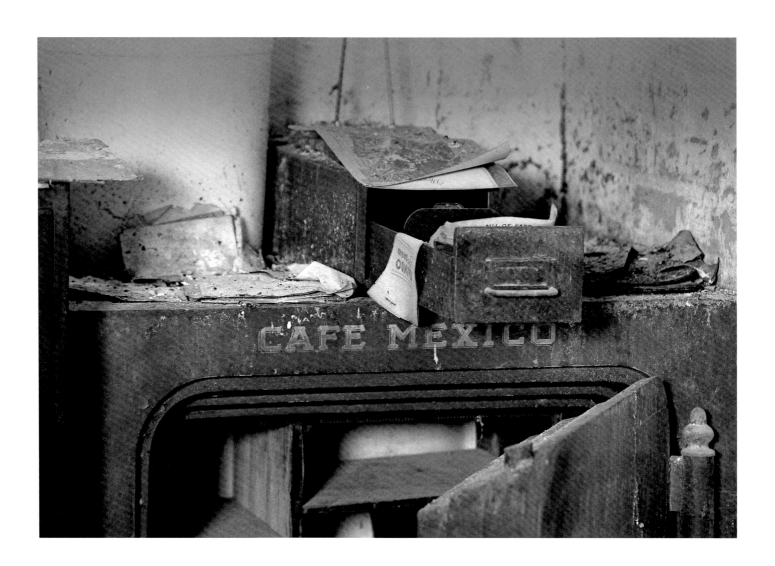

a German immigrant named William Gebhardt succeeded in drying and grinding chile powder. This powder, rarely used south of the border, led to the development of a distinctive Tex-Mex flavor in which chile powder was combined with Anglo and German gravies and meat sauces. By the time Jovita González was born, Anglos in the Southwest were regularly eating Mexican food—or at least food that restaurants called Mexican. They were willing to pay good money for it, too, particularly at Anglo-run enterprises that soon began to feature murals of Mexicans loafing in sombreros, often with prickly pears, adobe houses, and missions in the distance.[10]

The traditional building materials of the borderlands—adobe and handmade brick—also enjoyed a remarkable renaissance in American culture at large. A new generation of artists and architects rediscovered the virtues of these materials and used them extensively in their buildings. Texas architect O'Neil Ford, whose career began about the same time as González's, proclaimed that "old bricks and bricks made in Mexico were aesthetically more pleasing" than manufactured ones. Like the earlier rise of the Arts and Crafts movement and the revival of New England colonial architecture, for Ford and others like him the best building was one with "humility and suitability to its site, surroundings, function, and historical context." Where stark white clapboards and uniform industrial brick had once reassured newly arrived Anglos that they could transform the borderlands into the image of their own culture, adobe and "Mexican" brick could now help Americans to make themselves truly at home in the Southwest. The world of commerce, industry, and big cities left many feeling hollow; authenticity and rootedness had a new appeal, particularly once the Depression seemed to shatter the prosperity that the modern economy had created. Americans thus began to value what they had once denigrated. Maybe there was, after all, something to be learned from people who had made themselves at

home for centuries in some of the continent's most remote and harsh places. The stories captured by González and other folklorists celebrated endurance and cleverness in the face of adversity, accomplishments that spoke to the psychological needs of Americans in the midst of the Depression and the Dust Bowl. Particular places might be worth saving and creating, too. The federal government hired Ford to restore La Villita, the old Mexican quarter of San Antonio. Santa Fe began to market its distinctive adobe structures as tourist attractions, and its Anglo Masonic Lodge rejected a neoclassical design for its new lodge building in favor of a Mission-style structure. Intellectuals, artists, and wealthy transplants like Mabel Dodge Luhan and D. H. Lawrence became enchanted with northern New Mexico's landscapes and started commissioning adobe homes for themselves. The places that borderlanders had created, that Jovita González tried to capture in her work, had seeped into the American consciousness.[11]

If some Americans found that borderlands architecture could fulfill a spiritual yearning, then others found themselves thinking about the border for much more prosaic reasons. Mexican immigration briefly became a pressing national issue in the chaos of the Depression, when the government assuaged white hostility and economic desperation by deporting hundreds of thousands of Mexicans and Mexican Americans during the 1930s. In the previous decade, when most Americans thought of the border, they thought above all about liquor and sex. Prohibition, which became the law of the land in February 1920, made a quick trip to the border the easiest way for many Americans to buy a drink. Well-situated border towns like Tijuana had long catered to the tourist trade, but Prohibition was a godsend for them. The border offered for easy money what most people could get at home only with much greater expense and trouble. "They have either sorrows to drown

or pleasures to accelerate in a way that is relatively difficult and expensive and sometimes socially inexpedient at home," one journalist observed of American border crossers. "The real thing, obviously and always sought in a border debauch, is to carry the memory of from two to nine drinks back to some town like Coon Rapids or Memphis, and to be able to say at the next gathering of cronies or lodge brothers: 'Lemme tell you, li'l ole Juarez is some town to raise hell in, and boy we sure raised it.'" Countless such trips brought the border into American

consciousness in another way: by the 1920s, pornographic cartoon books in the United States were popularly known as Tijuana Bibles. The border's risqué reputation was further secured by a series of powerful radio stations, located just south of the river to avoid the more restrictive American signal limits. Boasting station names that began with the letter X, these were among the first to play the once-controversial hillbilly, country and western, Mexican *ranchera,* and rock and roll music. The stations were so powerful that, like the other cultural echoes of the border, they could be heard across most of the country. More than one Texan swore

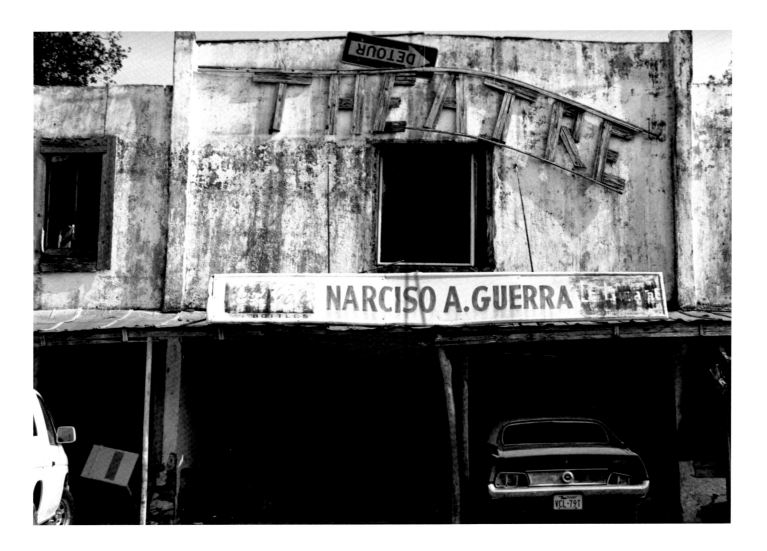

that birds flying near the transmitters dropped dead, and June Carter Cash claimed that even barbed wire could pick up the signal.[12]

Roma, not too far from border blaster stations to the north in Nuevo Laredo and to the south in Reynosa, was neither Santa Fe nor Tijuana. It boasted no red-light district and attracted no appreciable tourism or artist colony. But it did play a role in the percolation of borderlands culture in American life. The town and its

surroundings were the seedbed of Jovita González's writings. And they also attracted at least one outsider, whose motives for coming paralleled those of so many Americans who discovered an appreciation for the people and places of the borderlands. In the late 1930s, as González turned away from folklore and more to the demands of high-school teaching and married life, Virgil Lott explained to the predominantly Anglo readership of a South Texas newspaper: "I live in one of the most isolated of border towns. . . . In Roma I find peace and quiet and the company of kind friends, albeit their skin is darker than mine and they talk another language, but underneath blue denim shirts beat hearts that are as pure as gold." Originally sent to the town as an immigration inspector, Lott was drawn back to Roma in his retirement "because of its quiet and sereness [sic] and because of its allofness [sic] from the mad rush of every day commerce." While most of his countrymen still perceived Hispanics as a foreign and exotic population, Lott found his neighbors to be admirable pioneers: "I love to live in Roma because of its traditionally historic background, because it is surrounded by hills which have looked down upon two centuries of struggle on the part of a people who have fought against desperate odds to maintain a foothold in a region almost devoid of natural resources. That they have done as well as they have, with the odds almost a hundred to one against them, is marvelous to say the least of it."[13]

An interest in the culture of places like Roma, of course, didn't necessarily mean equal treatment or respect for Hispanics themselves. It was one thing to live in or visit an adobe house, and another to welcome (as Virgil Lott actually did) somebody with a last name like González as a neighbor or pay them a fair wage for their labor. Wealthy Californians might flock to the mission plays commemorating the Spanish evangelization of the West Coast, but they told themselves that there was no connec-

tion between the noble Spanish and the increasing number of Mexicans in their midst. Artists and writers might admire the rootedness and supposed contentment of New Mexico's Hispanic villagers, but they could be appalled when these colorful people dared ask for electricity and indoor plumbing. White men might pay for the services of Mexican prostitutes, but that didn't mean that they wanted Hispanic women as wives or daughters-in-law. Literary-minded Anglos might enjoy the folk tales recounted by Jovita González, but most would stop well short of hiring somebody like her as a professor or recognizing her accomplishments as an artist. As she complained in 1937, "when one sees the great sums of money spent to reconstruct the Spanish missions and other buildings of the Latin-American occupation in our country, one cannot help but wonder at the inconsistency of things in general. If Anglo-Americans accept their art and culture, why have they not also accepted the people? Why have not the Latin Americans been given the same opportunities that have been given other racial entities in the United States?"[14]

Gilberto Garza

JOVITA GONZÁLEZ WAS ABLE TO return to Roma from time to time, but not all of those who left were so fortunate. Such was the case with Gilberto Garza. The sixth of seven children in a long-established Nuevo Santander family—his great-great-great-great-grandparents had come with Escandón, a fact the family still remembers with pride—Garza was known around town mostly as "Beto." He was twenty-two when the Empire of Japan bombed Pearl Harbor. Early the next spring he enlisted in the army, volunteering his services for the duration of the war. Beto Garza was not alone in his decision, as more than seven hundred men from Starr County enlisted during the war, including the twenty-three who signed up the same day he did.[1]

Garza was inducted as a private first class into the 160th infantry division, alongside soldiers from across the state. (The government classified Hispanics as "white," ensuring that almost all served in integrated units, though many seemed not to embrace that status. Garza, like about half of the men with whom he enlisted, opted to select "other" as his race; there was no Hispanic, Latino, or Latin American designation.)[2] His division was dispatched to the Pacific, where Garza was witness to some of the most demanding and brutal experiences of World War II. The land battles of the Pacific often degenerated into point-blank combat in a terrain and climate that were hazards in their own right. Heat, heavy rain, dense jungle vegetation, and the difficulty of resupply exposed Garza and his comrades to such tropical illnesses as malaria and dysentery. Surviving soldiers recalled the stench of human

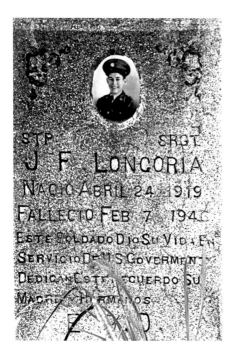

corpses mixing with swamp smells. Along with the dangers of combat against an entrenched and determined foe, these conditions led some to self-mutilation, suicide, and psychological breakdown.[3]

Garza endured as the tide of the war turned, earning eight medals and decorations, including two bronze stars. In early 1945 he found himself part of one of the largest American amphibious operations of the war, the attack on Luzon Island in the Philippines. As kamikaze pilots sank two dozen ships around them, Garza and his fellow infantrymen came ashore. He was still alive when the U.S. forces took the capital of Manila in house-to-house fighting. By February, the most intense fighting was in the mountainous northern part of the island. Two weeks shy of his twenty-sixth birthday, only a few months before Allied forces entered Berlin and six months before Japan's surrender, Garza died from wounds he sustained in battle.[4] Two more of the twenty-three men who enlisted with him were killed in action, along with thirty-eight other men from the county.[5]

Two years later, Beto Garza's remains were sent home in a flag-draped casket that his brothers and nephew picked up at the railroad depot in Rio Grande City and drove back home. His funeral was a deep sorrow for his parents and six surviving siblings, only made worse by the two years' wait for his physical return. But others were there to share the grief: virtually the whole town turned out for his burial, as it had for the other native sons lost to the war. A few years later, Roma's government named a street after him.

The funeral was thus also a reminder of the virtues of living in a place like Roma, as another, similar service made searingly clear. Like Garza, Felix Longoria was a native son of South Texas. Like Garza, he enlisted in the army and was killed in the

Philippines in the waning days of the war. Like Garza, his body was returned a few years later to his grieving family, who intended nothing more than to bury him in his hometown after a dignified service in its funeral parlor. Like Garza's kin, the Longorias were deeply rooted in South Texas; twenty years earlier, Felix's father was paid by the city to construct a fence dividing the Mexican and Anglo sides of the town cemetery.[6]

But unlike Garza, Longoria was from a town—Three Rivers, Texas, just south of the Nueces River—where Hispanics lived in a world run by Anglos. The trouble began with the funeral home, where the nervous director would not let Longoria's parents and widow use the chapel because "the whites would not like it." Longoria's stunned widow Beatrice turned to Dr. Hector García, a physician in nearby Corpus Christi who had formed an organization of Hispanic World War II veterans intent on fighting racial discrimination. The director insisted to García that the Longorias couldn't use his funeral home, describing "how the Latin people get drunk and lay around all the time . . . we have not let them use it and we don't intend to let them start now . . . the whites here won't like it."[7]

Sometimes insulting the dead can infuriate the living like nothing else, and that was exactly what the Felix Longoria affair (as it came to be known) did. García sought help by telegramming prominent officeholders, from President Harry Truman on down to state officials. On January 11, 1949, García called an emergency meeting to be held at the "Mexican" elementary school in Corpus Christi. That evening, people poured in from the fields, packing sheds, docks, and wherever else they worked to gather at the school auditorium. By the time García read a telegram from the newly elected U.S. senator Lyndon Johnson offering to secure a burial for Longoria at Arlington or another military cemetery, more than a thousand people stood

and cheered for Johnson, for the deeply moved Beatrice Longoria, for themselves, and for their people.[8]

Newspapers from as far away as New York, Detroit, and Buenos Aires covered the story on their front pages. Stung by the publicity, Three Rivers officials insisted that of course Longoria could be buried in his own town, stating publicly that the funeral home only feared intrafamily conflict, and whispering privately that Beatrice Longoria was a whore for taking up with another man. The mayor, the head of the Chamber of Commerce, the town's banker, and the town secretary pressured Longoria's father to disavow the campaign on his son's behalf, badgering him so relentlessly that he left for Laredo at the height of the crisis. Armed locals greeted a state investigative committee with curses and threats, brandishing weapons and hurling curses at its delegates.[9]

The family maintained its united public front. And so on February 16, 1949, as a cold rain fell, Felix Longoria, a humble private from an obscure South Texas town, was laid to rest at Arlington National Cemetery in Virginia. His parents, his widow, and their daughter, as well as congressmen, State Department officials, and diplomats from Latin America, watched as a squad of riflemen fired three volleys, a bugler blew Taps, and four uniformed soldiers held the flag over the descending casket. In death Longoria achieved a prominence and fame that eluded him in life. His burial cemented Hector García's organization, the G.I. Forum, as an influential civil rights group in Texas, and earned Lyndon Johnson deep and abiding support from Mexican Americans. A *corrido*, or folk song, memorialized his war service, and people from all walks of life wrote to Beatrice Longoria or Hector García, enclosing whatever they could spare, sometimes a few dollars and often just a field worker's average hourly wage of twenty-five cents. "Enclosed you find a money order for $5.00—five dollars,

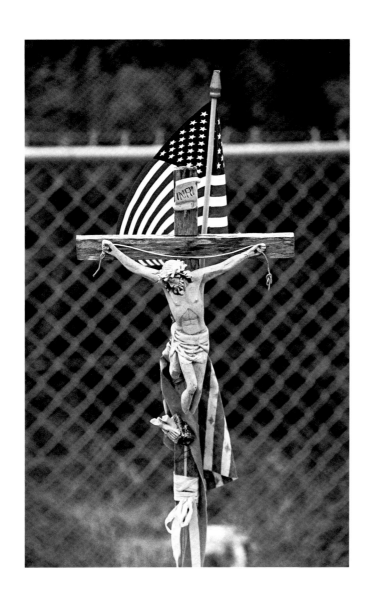

which I am sending to the family Longoria," wrote Mr. and Mrs. Roy Navarro, "so they be able to make their trip to Washington. I was very sorry to hear about this boy funeral's not being admitted at this Funeral Home, to tell you I cry and Kept looking at my brother picture who died for the sake of his country, to, and who so far has been brought to the State's and had a nice Funeral with all the honor's, and it made us feel happy."[10]

It was the continuity of life in Roma that ensured that Gilberto Garza's family was not subjected to the same ordeal as Felix Longoria's. Segregation—the South's formal Jim Crow, the Southwest's less rigorous application of it to Hispanics, and informal measures elsewhere—was still America's way of dealing with its racial outcasts, but Roma and a few other places were still distinctive enough to avoid such a fate. Such was the bright side of the town's continued physical remoteness and of the insularity that had so aggravated Jovita González. (A priest traveling from Laredo during Garza's childhood was less impressed by Roma's isolation when it took him thirty hours to make the ninety-mile trip because a rainstorm had made the dirt road "almost impassable.")[11]

Nevertheless, the military service of so many men like Garza and Longoria demonstrated how much more tightly bound the borderlands had become to the United States. In some places dramatic changes in the landscape captured these ties. Wartime industry and military bases helped complete Southern California's transformation to an industrial and manufacturing powerhouse. The Manhattan Project made New Mexico, so much of which still lay in Hispanic and Indian hands, the birthplace of the atomic age. Roma and the rest of the Texas border saw no such huge projects or booming industries, but like the rest of the Southwest, their people

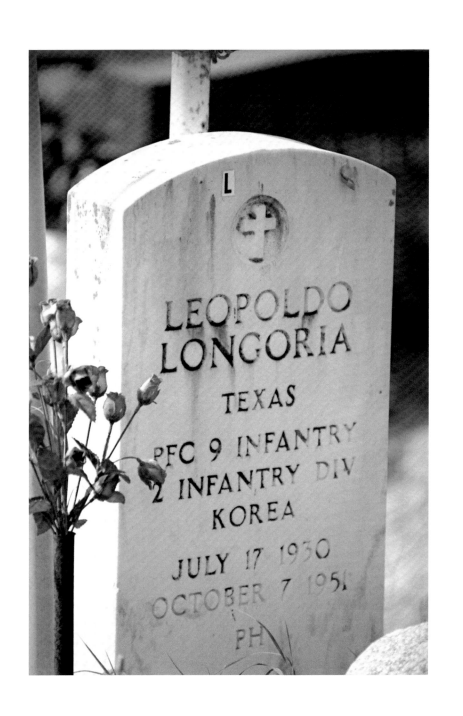

signaled their belonging to the United States in a more fundamental way: they actively embraced military service. Mexican Americans volunteered for duty at greater rates than the national average, intent on fighting for their country abroad and then for their rights as citizens at home.

This dual embrace of military service and the rights of citizenship was in some ways a continuation of the borderlands' past and in others a departure from it. People in Roma had felt the attraction of the United States from the town's earliest days, whether in the decision of José María García Sáens to seek his fortune on the north side of the Rio Grande or of Starr County rancheros to fight for the Union in the Civil War. Some Mexican Americans, including a leading South Texas civil rights pioneer, fought in World War I, although Hispanics, like many other Americans, were deeply divided over the U.S. entry into that conflict. On the other hand, however, the United States remained in a sense an occupying power: a South Texas play in the 1890s portrayed the devil as a U.S. Cavalry officer, and violent rebellions against American rule and Anglo racial chauvinism erupted in South Texas in 1859, 1891, and 1915.

If the United States could seem distant and even hostile, then in contrast Mexico was intimate and familiar, an unquestioned part of the fabric of daily life. When Garza was born, a quarter of the town hailed from Mexico, and more than forty percent of native-born residents had at least one parent from across the river.[12] The cross-border family, as well as economic and cultural ties with Mexico, continued to be a fundamental feature of life in Roma as Garza grew up. Weddings, baptisms, parties, and holidays frequently brought extended families together on one side of the river or the other, and brothers and cousins often jointly owned property and ran cattle on both. "To us, the border was just something that was there; it was not

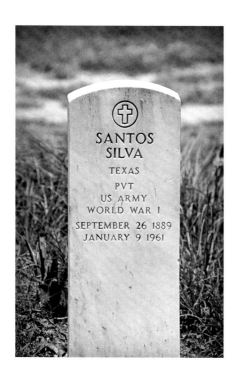

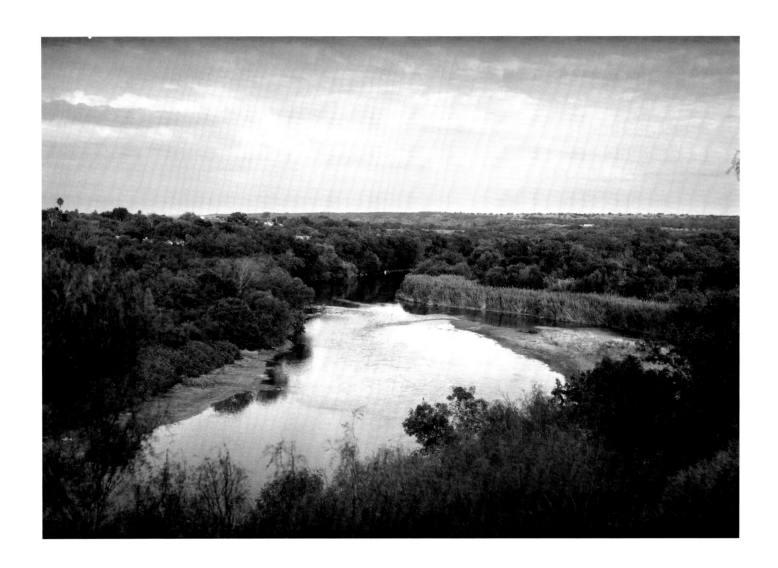

a blinder—same culture, same family on both sides," recalls a man who grew up in Roma in the 1940s and '50s. The river itself was a playground, its cooler waters enticing people to alleviate the heat with a quick dip. A graceful suspension bridge jointly built by American and Mexican companies in 1928 allowed easy crossing by foot, car, or horse, back and forth from Roma and the small satellite town of Mier that would later be named (after the Mexican president) Miguel de Alemán.[13]

There were laws on the books that might have made these routine crossings more fraught. In the 1910s, a few years before Garza's birth, the United States passed a set of laws mandating the strict inspection of immigrants and barring or restricting those deemed ill, impoverished, or illiterate. The Border Patrol itself was established in 1924, when Garza was four, in an overhaul of immigration laws meant to ensure that most new Americans would be Protestants from northern and western Europe. U.S. policymakers were more preoccupied with Asians—almost all of whom were completely banned from entry—and the heavily Jewish and Catholic eastern Europeans. (These immigrants would often dress up like Mexicans and memorize a few key words of Spanish in an effort to trick U.S. authorities into granting them passage.) The 1924 legislation didn't even mention Mexico or Latin America.

In some places these immigration provisions could be quite onerous, even demeaning, for those entering from Mexico: border crossers would be subject to humiliating inspection and compelled to enter chemical disinfectant showers if an immigration agent ordered them to. Such procedures began at the border in El Paso in 1917, after the city's mayor became so alarmed about the public health impacts of supposedly diseased Mexican immigrants that he began to wear silk underwear because a doctor had told him that lice could find no purchase on the fabric. The measures reverberated from El Paso, first to other major border

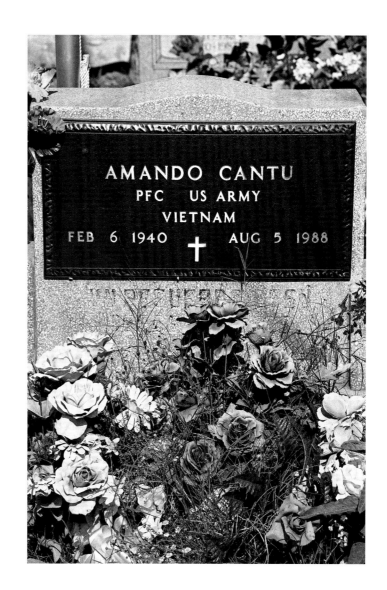

checkpoints, and then abroad. Some of Garza's counterparts in the European theater of the war witnessed the grim fruit that this inspection regimen yielded when they liberated the Nazi death camps. A few years after the El Paso station's medical officer began using the poison Zyklon B as the disinfectant of choice, German scientist Dr. Gerhard Peters included photos of large groups of naked Mexicans undergoing the disinfection in an article advocating the use of Zyklon B in Germany. Peters soon became managing director of a German company that mass-produced the poison during World War II; he was later tried at Nuremberg after his government used the airborne version of the chemical to kill millions in its gas chambers.[14]

Nothing like the Zyklon B cleansing happened in Roma, however, and the town remained closely knit to northeastern Mexico. The immigration and customs agents charged with enforcing both Mexican and American regulations were generally from the area and knew most border residents, reflexively waving them through. Spanish was the first language, and the few Anglo kids (generally the children of federal or state employees) quickly became bilingual. Many local children did not learn English until school. Mexican films were the mainstay of Roma's one movie theater.[15]

The experience of World War II did not attenuate these ties to Mexico, but it did make it easier for people from places like Roma to see that being a part of the United States might mean much more than a historical accident or an abstract and irrelevant legal standing. If the United States was retooling its vast industrial might and sending its young men across the globe to fight racism and tyranny abroad, then it had to stop practicing them at home—thus the visceral outrage at the refusal to let Felix Longoria's family use the chapel at Three Rivers. Like African Americans, Hispanics repeatedly drew parallels between the United States' struggle abroad and

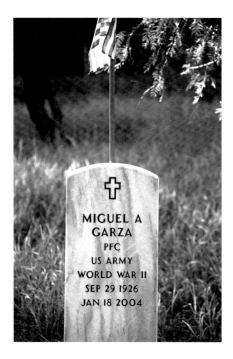

their own cause. Angry at the denial of service to uniformed soldiers in West Texas towns, one author sardonically noted that "Latin American . . . soldiers are not good enough to enjoy the rights of American citizens, but they are good enough to die defending their country. The Latins will feel just like the Jews in Germany."[16]

Outside of isolated enclaves like Roma, these high hopes collided with the reality of discrimination and exploitation. Children continued to attend segregated schools, people of all ages sat in the backs of theaters and were denied access to libraries and swimming pools, and in many places blacks and Hispanics were purged from voting rolls and jury pools. Racial violence continued to be a feature of daily life, as when a small mob in San Angelo, Texas, sent a Hispanic soldier into a month-long coma from a severe beating, or when a large mass of sailors and soldiers tore through the east side of Los Angeles for ten long days in 1943, assaulting any young Hispanic men in sight. But there was also measurable improvement. Unlike their black counterparts, Hispanics generally did not serve in segregated military units, and many young men had more to do with each other in Normandy and Okinawa than they had in San Antonio and Albuquerque. Small-town newspapers began mentioning Hispanic individuals outside the police blotter for the first time. The self-confidence earned on the battlefield, veterans' benefits such as the G.I. Bill, and work on military bases where federal anti-discrimination statutes applied allowed many to enter the middle class. A generation after their culture drew many Americans to Mexican food, old brick, and adobe, Hispanics made enormous strides as American citizens.[17]

This transformation was not so dramatic in Roma, where there weren't any "No Mexicans Allowed" signs to tear down, and where the few Anglos around happily accommodated themselves to Hispanic economic and political power. But even in

AN INDEPENDENT CANDIDATE

F. D. GUERRA
—FOR—
County Judge
STARR COUNTY

FOR A CLEANER AND BETTER COUNTY GOVERNMENT

Subject to Action of Democratic Primary, July 22, 1950

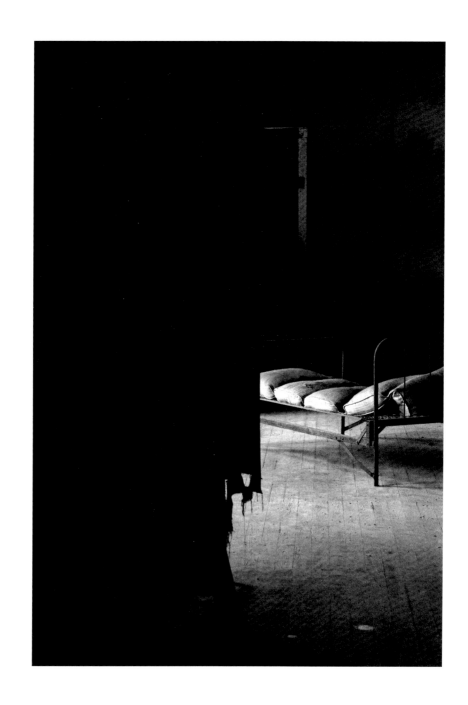

Roma, World War II was telling, not only for how it allowed people to think of themselves as Americans, but also for what that meant in local politics. The same political machine that had so angered Jovita González decades before lasted through the war years, with the Guerra family and its close associates monopolizing political power and using it to protect their own businesses from competition. The school system continued to be one of their primary assets. State investigations of electoral fraud and an abortive local opposition party had failed to dislodge the Guerras. But the war did: returning veterans, having seen something of the world and fought for its salvation, were unwilling to live under the thumb of what amounted to a small local aristocracy. In 1946, a year before Gilberto Garza's body was laid to rest, the New Party, headed by veterans, defeated the Guerras in an election for the first time in memory. It was not a victory in the same way that a civil rights bill or the burial of Felix Longoria at Arlington was, but it was one of many signs that Roma had become Americanized.

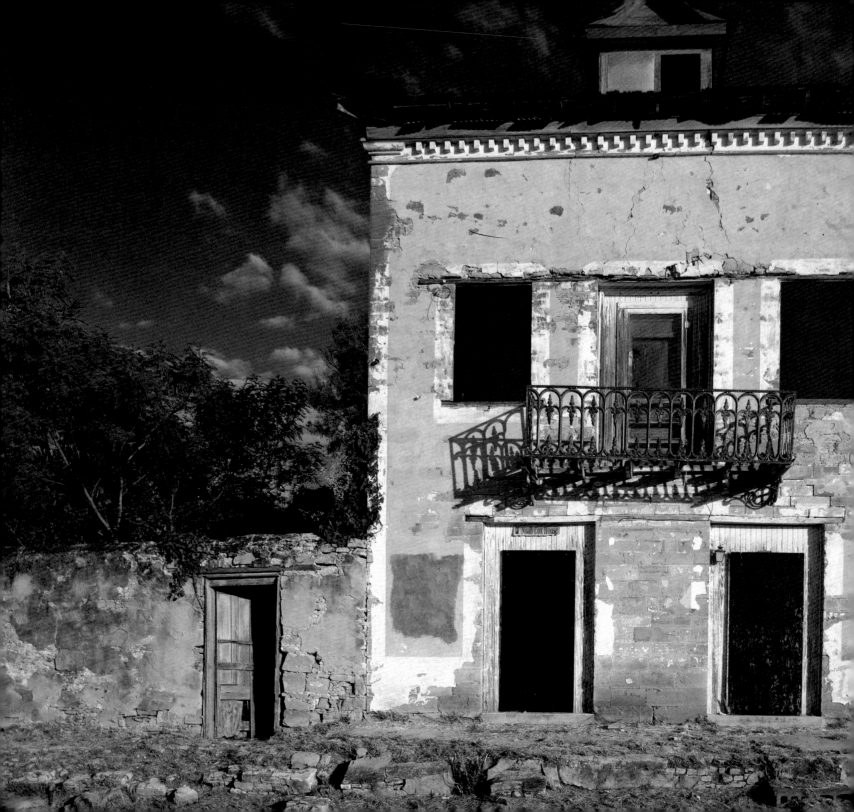

Elia Kazan

IN 1951, FOUR YEARS AFTER GILBERTO GARZA was buried, Roma found itself, for the first and last time, at the center of a national cultural drama. Somehow the Hollywood director Elia Kazan, fresh off the triumph of his movie adaptation of *A Streetcar Named Desire*, had picked the still-obscure town to be the site for his next epic, *Viva Zapata!* Kazan set up shop in the small town, bringing such luminaries as Marlon Brando (who played the title role) and Anthony Quinn (as his brother) along with the rest of the cast and crew to make John Steinbeck's script into a movie. Many of the residents of Roma and surrounding towns earned themselves a sort of immortality in popular culture by appearing as extras, from men on horseback (including one who stepped in for many of Brando's riding scenes) and humble peasants to women mourning the revolutionary leader's assassination.

The original plan that Kazan and Steinbeck pursued was to make the movie in Mexico. Emiliano Zapata, a peasant from a village in the southern heartland of Mexico, remained a leading Mexican national hero some thirty years after his assassination, as he does today. There is no U.S. parallel to Zapata, though some combination of the fervor and martyrdom of John Brown and the agrarianism of Thomas Jefferson might come close to capturing his enduring influence. Zapata's insistence that the land should be returned to the ordinary people from whom the elite had taken it helped to topple a dictatorship in 1911, survived years of civil war and a mass exodus from the country, got him killed by a more conservative faction of the Mexican Revolution in 1919, and enshrined him as a hero for the countless millions who

143

continued to dream of the dignity and independence that a bit of land might bring. The Mexican government, which claimed to represent the hopes of the Revolution, touted him as a founding father of modern Mexico, as did many of those who accused it of betraying Zapata's vision. John Steinbeck had met many of Zapata's relatives and surviving lieutenants, and he knew southern Mexico well enough to scout out potential locations for Kazan. But the project was too politically fraught for Mexican officials, who insisted on editorial control over the script. The film, even Steinbeck agreed, would have to be made in the United States.

Fortunately, there was enough of Mexico north of the border. After driving "all along the US-Mexican border, along the back roads until we came on this town," Elia Kazan picked Roma because "it still looked like . . . a Mexican town." It wasn't that he cared for it: he called the town "very sleepy, debilitated," and "far from what is thought of as civilization," suffered in the heat, complained about the abundant rattlesnakes, and chose to stay nights with his family fifty-five miles away in McAllen. He got what he came for, though: not only were most of the scenes shot in and around Roma, but the location inspired new ideas in him "over and over again." Even the musical score, by leading film composer Alex North, was based on tapes made of local musicians performing classic songs of Mexico and the ballads of its Revolution. Portscheller's buildings still showed their grace and power, drawing Kazan to shoot over and over again in the plaza. The final scene, in which anonymous Mexican peasant women, all played by local extras, move from the shadows of the plaza's edges first to mourn over and then to wash Zapata's corpse, struck Kazan as "one of my favorite moments in film—directed by me or anybody else."[1]

It was fitting that this epic about the history of Mexico was made in the United States in a border town, for the two nations were growing ever more entwined. Roma

remained Mexican enough to work brilliantly for Elia Kazan, but the Mexican Americans of places like it were becoming culturally and politically more and more American. The momentum for civil rights unleashed by World War II continued, making it easier for people of Mexican descent to envision a day when they would achieve equality and prosperity as American citizens. Teenagers preferred American to Mexican films, and were as likely to dance to Bill Haley and the Comets as to ranchera music. Roma itself started to look more like other American towns: the middle class's new houses were low-ceilinged ranch homes with air conditioning rather than derivatives of Portscheller's regional style, and the plaza was largely dead by the time Kazan blew into town, with new businesses choosing to locate a few blocks north on the state highway.

At the same time, more and more Mexicans were migrating to the United States, providing the labor that made possible key agricultural and industrial sectors, and ultimately remaking the American landscape. The first great wave of Mexican migration happened during Zapata's heyday in the Revolution, as perhaps a tenth of Mexicans fled the violence for work in the United States. Some of the extras playing Zapatistas were surely the children of revolutionary veterans (as was Anthony Quinn), or veterans themselves. The Depression brought a temporary halt and even reversal of the migration from Mexico, with hundreds of thousands being deported south of the border. The dramatic economic recovery during the Second World War and the postwar boom created a strong demand for labor, which Mexican workers were eager to fulfill. Some came illegally across the unfortified border, but at least four and a half million came under the auspices of the Bracero program, a guest-worker system created by both governments and in operation sporadically from 1942 to 1965. Some returned to Mexico at the end of their contracts, while others

stayed permanently in the United States. Remittances—wages brought or sent back to Mexico—helped revitalize moribund rural economies, even in Zapata's hometown, and underwrote new construction. The very shape of modern Mexico was unthinkable without the United States, just as the neighborhoods of Los Angeles and the harvests of the American West were made possible by Mexico. Most Americans didn't and still don't know who Emiliano Zapata was, but whether they realized it or not, when they watched *Viva Zapata!* they were watching American history, too.

On some level Elia Kazan recognized this. He was drawn to Zapata's story because it spoke so powerfully to the dilemmas that he faced as an American. Like many idealists during the Depression, Kazan had flirted with Communism, briefly joining the party. Later, McCarthyism at home and the Cold War abroad dominated American politics, forcing people like him to make hard choices. Kazan himself was haunted for the rest of his life by his decision to name other former party members to the House Un-American Activities Committee during the height of the Cold War paranoia. In Mexico's revolutionary icon he found a figure who also wrestled with the corruption of power, ultimately forfeiting his life by declining to seek absolute mastery over Mexico. The Emiliano Zapata of Kazan and Steinbeck was heroic, but at the same time utterly human. Americans had never seen such a full and compelling depiction of a Mexican character in film.

Nonetheless, Elia Kazan missed most of the connections between Mexico and the United States, the connections that had made Roma so suitable for his film. All people of Mexican descent, and the places they had created, still struck him as terribly foreign. "During our time in Roma, Texas," he later recalled, "I came to love the Mexican people who'd settled there, and forgot all about their country's official censor and Department of Defense." As even a quick look at the cemetery would have

told him, most people in Roma were from there and considered the United States their own country; indeed, Roma was more native-born than it had ever been, with barely one of thirteen residents having been born in Mexico. (Unlike earlier migration, which was mostly local, after the war the larger overall migrant stream—from all over Mexico—passed through places like Roma on the way to the larger and more economically vibrant population centers of the American Southwest and Midwest.) In part, his confusion came from the fact that Kazan had difficulty escaping crude racial stereotypes. Even in the 1970s, after the major triumphs of the civil rights movement, Kazan explained the rivalry between Marlon Brando and Anthony Quinn with the observation that "Quinn is only half Mexican, but he's typical. The Mexicans I've known are the most suspicious people I ever met in my life, except the Puerto Ricans, who are worse."[2] Even though Kazan put Roma in the plain view of millions, its history remained hidden to him.

Others were in a position to understand the cultural blending that made places like Roma possible. Mexican Americans loomed as large as Mexicans in John Steinbeck's life and work, for example, and the decision of Antonio Quiñones to go by the name Anthony Quinn in his professional life did not mean that he turned his back on his Mexican family. But at the same time, Kazan's blindness was understandable. "Mexican" continued to be a racial term for most Americans, rather than a national one. And the border itself became harder to cross, with an increasing number of Border Patrol agents deporting those who migrated illegally, even as employers welcomed Mexican labor with open arms. Among other things, in South Texas this meant that traditional brick-making enterprises had to move south of the river, since the skilled Mexican craftsmen they relied on could no longer cross back and forth with ease. "Mexican" brick was now literally Mexican, and the border was a more formidable barrier between the two entwined nations.[3]

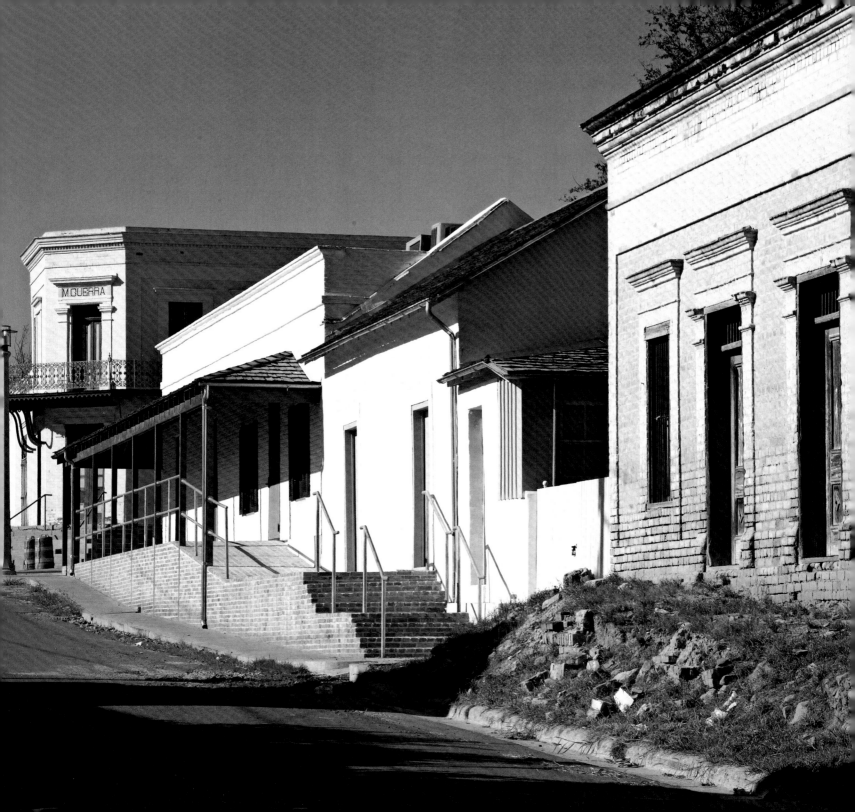

Hugo Van Den Bussche

ONCE ELIA KAZAN AND HIS CAST and crew packed their bags and headed back to Los Angeles, life returned to normal in Roma. The influx of people and money brought by their film was short-lived. The town was far enough away from the major international rail and highway connections in Laredo and McAllen to be ignored by most travelers and shipping companies, though locals continued to cross the river both ways to visit friends and family, and the faded majesty of the plaza drew occasional tourists. The town slowly grew in population, along with both sides of the rest of the border. The so-called Sunbelt was the fastest-growing region in the United States, with Southern California, Phoenix, and several towns in South Texas boasting decades of unbroken expansion. On the Mexican side, a border industrialization program attracted heavy industry to the nation's northern edge, where foreign investors would have access to the U.S. market while still benefiting from the much lower wages of the Mexican economy. The signing of the North American Free Trade Agreement (NAFTA) in 1994 gave the border boom further momentum by creating a common market in the United States, Canada, and Mexico for most goods and services.

NAFTA was designed to expedite the free flow of capital and goods, not people, but by the twenty-first century the migration from Mexico had become one of the largest population movements in world history, with perhaps six hundred thousand Mexicans moving north each year. Twelve to fifteen million people, at least half of them from Mexico, now reside in the United States without permission. One of every

153

eleven people born in Mexico and still alive now resides in the United States, and by 2050 perhaps a quarter of the United States will boast Hispanic ancestry (of which half or more will be Mexican). This is as profound a demographic transformation as either nation has ever experienced, and it makes the kind of encounters that had long happened on the border seem less like marginal sideshows to American history and more like premonitions of what was to happen nearly everywhere.

Although nearly half of Roma's current residents were born in Mexico, a level not seen since the nineteenth century, the larger migrant stream was headed farther north, to the urban centers of American economic life. For most of these travelers, the border region was a place to be crossed on the way to somewhere much richer, with more opportunities for work. (The poet Benjamin Sáenz, who spent most of his childhood in the Texas borderlands, still remembers his incredulousness when his mother told him that people died to get to his country. Looking at his family's out-house and the pipe that brought them water from a fickle well, he couldn't "fathom why anybody would risk death for the chance to live like us.")[1] Roma, located in what had become one of the nation's poorest counties, had comparatively little to offer in terms of employment. No auto parts, textile, or electronics manufacturers located nearby, no shipping companies set up shop, no executives moved to town to live just across the border from their plants. City government continued to be the largest employer, and most young people who did well in school left and never came back.

But Roma was still on the border, and that single fact continued to shape the town. Hugo Van Den Bussche could see this simply by looking out at the plaza from the church. Sent in 1992 by the Oblate order to minister to the congregation of La Iglesia de Nuestra Señora del Refugio (the Church of Our Lady of Refuge), the priest found that his church was aptly named. Every day people darted in and out of the

plaza's historic buildings, waiting for the break in the Border Patrol's surveillance that would allow them to reach the sanctuary. As a matter of practice, immigration authorities refused to enter churches to search for people who were in the country illegally. Migrants knew this, and many found refuge in the sanctuary, resting on the pews, using the bathrooms, and by some accounts drinking water and eating food provided by the church. Once they were better rested and thought the coast was clear, they left to continue their journeys to Houston, Chicago, New York, or wherever they were bound.

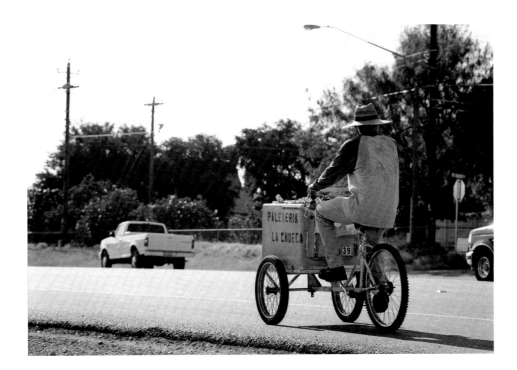

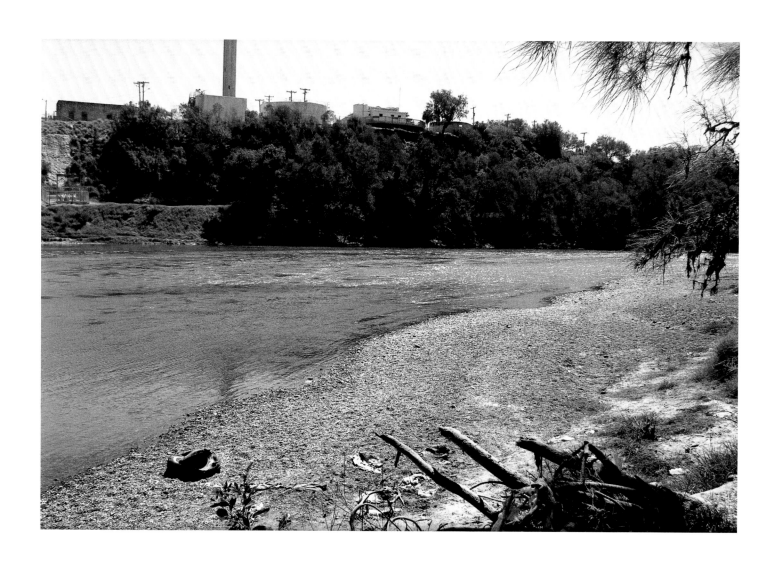

Van Den Bussche was moved by the stories of these migrants. He knew that their journeys combined something of Ellis Island with either the Underground Railroad or the Middle Passage, depending on how they turned out. A long bus ride to a northern launching point such as Miguel de Alemán (preceded by a crossing of Mexico's dangerous southern border in the case of immigrants from the rest of Latin America) sets the stage for the actual border crossing. A few minutes in an inner tube to cross to Roma or another point, a dash across a highway, or interminable hours spent hidden in a truck takes a migrant into the United States. From there, if he or she eludes the Border Patrol, relatives and friends might be reached after another car ride or grueling days of more walking. The journey might end with a joyous reunion with a spouse or child. Or it might conclude with an excruciating death, as for the scores who lose their lives in the Arizona and California desert every summer, or the nineteen who suffocated in the back of a parked tractor-trailer in Victoria, Texas, in May 2004, clawing their fingers to the bone in a desperate attempt to escape. One person has died trying to cross the border nearly every day since the mid-1990s.[2] And even those who escape this fate are vulnerable to violence, rape, and the theft of years of savings while on their journey.

The people darting across the Roma plaza had to elude the U.S. government, which tries to halt illegal immigration, or at least seems to. By the time that Van Den Bussche left Roma, the presence of motion detectors, hidden cameras, biometric screening devices, radar balloons, and (farther west) steel fences were tangible evidence of the billion and a half federal dollars spent each year on border enforcement, as were the SUVs, ATVs, helicopters, hovercrafts, boats, and airplanes used by the thousands of Border Patrol agents. This effort results in the arrest of an undocumented immigrant about every thirty seconds of every hour of every day of

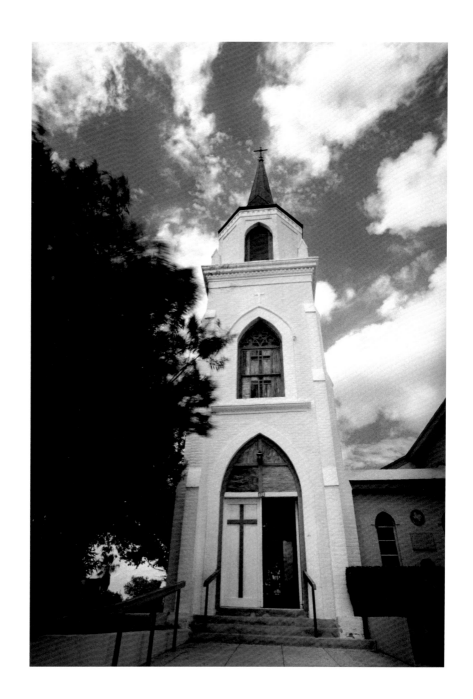

the year. But they are more than matched by the determination and ingenuity of those who are crossing. Coyotes, those who charge migrants to lead them across the border, have painted their trucks to look like television vans, FedEx trucks, or even Border Patrol vehicles. One man disguised himself as a tumbleweed and tried to roll into the United States. Many have attached cow hooves to their feet to throw off trackers. Women and children have hidden themselves in modified van gas tanks. If these travelers are in a sense doing battle with the Border Patrol, then in the aggregate they have clearly won.[3]

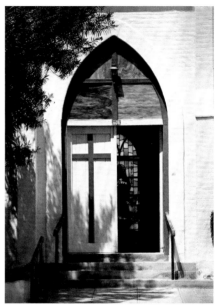

These contested migrations compelled the attention of increasing numbers of people whose circumstances in life were far removed from the voyagers who took such risks. By the time Van Den Bussche had become Roma's parish priest, the national intellectual and cultural establishments of both Mexico and the United States had begun to take their shared border seriously as a place where history was being made, an inescapable fact of life for many of their countrymen, and a worthy subject for their best minds. The Mexican state started collecting and supporting literature from its north, previously looked down on as a cultural backwater. Carlos Fuentes, perhaps the nation's leading writer, published *La frontera de cristal* (The Crystal Frontier), a Rashomon-like novel consisting of nine stories of border crossing and other encounters between Mexicans and Americans. His characters came from radically different walks of life, but they found themselves bound up, wittingly or not, in the same economic, social, and erotic world.[4]

At about the same time, the American novelist Cormac McCarthy moved to El Paso and began writing epics in which seemingly archetypal Anglo-American cowboy heroes find themselves revealed and transformed by the borderlands, immersed in the shared pasts of the American West and the Mexican North. McCarthy hauntingly evoked the ghost landscapes of the region—pre-Columbian ruins, abandoned ranches, derelict churches, almost hallucinatory visions of the once-mighty Comanche—to reveal the ephemeral nature of modern civilization, itself destined to crumble into dust. Bruce Springsteen made a similar turn southwest, finding the same dramas of love, redemption, broken dreams, and undying aspiration that he had captured in the blue-collar Northeast at play on the border, where Sinaloa cowboys buried their brothers in the California methamphetamine belt, Border Patrol agents fell in love with their prey, Tijuana street kids sold themselves in San Diego

parks, men drowned off the Matamoros banks yearning for the embrace of their lovers, and despite it all people couldn't stop dreaming of better lives on the other side. The border, the man from New Jersey knew, was one of the great stories of American life, and he explicitly linked it to past national dramas and the art that they had inspired: his first border songs appeared on an album titled *The Ghost of Tom Joad*.[5]

What these men had made the subject of compelling art had also become the source of ongoing political and social conflict, one whose twists and turns ensnared

Roma's priest. To most Mexicans, including many of the migrants themselves, the departed millions are visceral reminders of the failure of their nation to provide its citizens with opportunity and prosperity. While sorrow and shame are the strong undercurrents in most Mexican film, novels, and press coverage of emigration, in the United States anger is the dominant tone. One group that has organized private citizens to help patrol the border warns that the United States is being "devoured and plundered by the menace of tens of millions of invading illegal aliens," prophesying that "future generations will inherit a tangle of rancorous, unassimilated, squabbling cultures." Fear of terrorism after 9/11 gave an added edge to calls for effective enforcement of immigration rules.[6]

Residents on both sides of the border have their own grievances about illegal migration. In Arizona and New Mexico, ranchers complain of cut fences, opened or destroyed gates, livestock death, litter, car and foot traffic at all hours of the night, and threats of violence from armed smugglers of drugs and people. Residents of some Mexican border towns claim that they have been overrun, seemingly overnight, by cheap hotels, hordes of transients, and the predators who make a living off them. Large portions of the border itself are trashed. One writer has described the "thick, mushy carpet the color of green vomit" that lines the most frequently crossed portions of the Rio Grande in South Texas: "Beneath the garbage bags lay other garbage bags in deeper decay, hundreds, no, thousands of individual garbage bags. Each individual bag had once been filled with a change of clothes for the new immigrant. . . . Emptied and abandoned, the plastic jetsam baked under the Texas sun and was transformed into a subterranean fungus."[7]

Borderlanders, even those who grew up swimming and playing in the Rio Grande, now speak with fear of the river, avoiding it when they can. One person

who has lived in Roma all his life reflects that he used to regularly talk to migrants crossing his property—"nice honest people just coming in to work," they seemed—but now sees fear and desperation in their eyes. He still goes to his ranch, but does so warily—and armed. Things are similar on the Mexican side, where migrants strike many longtime residents as potentially dangerous outsiders too numerous and too desperate to be treated with anything other than great caution. Indeed, most of the violence occurs on the Mexican side.[8]

The large amount of drug traffic across the border exacerbates such fears. The United States' demand for illegal drugs is so enormous and backed by such wealth that the profit to be gained by supplying it has proven irresistible, especially in such impoverished places as Roma. Like illegal migration, the drug trade has a long history. Anti-drug laws were passed in both countries in the early twentieth century, but they never proved any more effective than Prohibition in preventing people from buying the substances that they wanted. Mexico provided large portions of the marijuana and heroin consumed in the United States over the twentieth century, but crackdowns in the 1980s on air and sea routes from Latin America to Florida made Mexican drug operators significant middlemen for all of Latin America's supply. Enormous quantities of banned substances are regularly seized along the border, as when three brothers living northwest of Roma pleaded guilty to bringing some 185,000 pounds of marijuana, worth around $150 million, into the country. But still the drugs come, ferried across the river, hidden in cars and semi trucks, packed onto mules, jammed into airplanes, carried in the backpacks or body cavities of desperate migrants. More than half of the annual cocaine seizures along the border take place in South Texas, where marijuana is so abundant that district attorneys don't even bother to prosecute cases involving less than a thousand pounds of it.

The illegal commerce that William Emory observed in Roma in the early 1850s has taken on new forms, but it continues to be a major feature of border life. And it is a conspicuous one in a small town like Roma, where a parish priest could not help but notice the huge new house or expensive car of a resident with little apparent income, something the anonymity of life in a bigger city might have obscured.[9]

The residents of towns like Roma suffer more of the negative consequences of this steady flow of banned substances and people, but they also express deep skepticism about the ability of any government to stop it. The "war on drugs" is more visible along the border than anywhere else, yet people here know that consumer spending in many border towns more closely tracks the marijuana harvests than it does factory paydays. (And their experience with the scope of cross-border commerce makes them doubt the impact of the drug interdictions that authorities trumpet as proof of their commitment to the war on drugs. About nine large tractor-trailers, for example, could satisfy the annual U.S. demand for cocaine. Those who see more than a million trucks cross into Laredo each year, for example, have no difficulty believing that there will always be plenty of cocaine for the American market.) Recent proposals to build an expensive wall the length of the entire border provoked widespread derision in the town.[10]

Perhaps this blend of resentment and realism accounts for what happened to Hugo Van Den Bussche after he openly told the press about his treatment of migrants. Like other priests, he openly preached against the drug trade. But drugs were one thing, and human beings another. The priest had no doubt where his loyalties lay. Neither the United States nor Mexico existed when Jesus of Nazareth walked the earth. It was not that Van Den Bussche was an advocate of a particular law or policy,

just that nations themselves did not occupy a prominent position in his moral hori-zon. "The Lord teaches that you should give food to the hungry, money to the needy and visit the sick in the hospital," he told a reporter in the summer of 2001. "People need food and water—that's the way that I look at it."[11]

Others didn't look at it that way at all. Many of Roma's leaders saw the publicity as a black eye for the town, something that would scare off tourism, discourage busi-nesses from locating there, and keep a flow of people moving illegally through the

town's heart. It might even convince the Border Patrol that the town didn't care about the constant breaching of America's borders. And this could harm everybody in Roma: constructing the agency's large detention and office facilities could bring hundreds of badly needed jobs to communities with high rates of unemployment. The payroll, with field agents earning two or three times the average local salary, would be a permanent boost for the economy and school system finances of what remained one of the poorest regions in the United States. There were also less obvious benefits to having lots of Border Patrol agents around—they were often the only law enforcement personnel able to quickly respond to emergencies in rural areas, and even in town they could be called upon to provide backup.[12] So Roma's leaders saw the charismatic priest's open aid to migrants as a threat to all of the town. They used their connections to the church, nurtured over generations, to have him deposed. Shortly after making extensive comments to the press in the summer of 2001, Van Den Bussche was removed as parish priest and sent to the Oblate seminary in San Antonio. Under a new priest, the church doors stayed locked when services were not being held.

The abrupt end to Van Den Bussche's tenure as Roma's pastor did not mean that the town's political establishment welcomed all border enforcement. If flouting the law threatened the town's well-being, then so might a heavy-handed, militaristic enforcement of it. In the summer of 2007, the Department of Homeland Security announced plans to build a barrier along much of the border, with early construction scheduled for South Texas, including Roma, where the wall might cut through one edge of the plaza. The plan provoked an intense political backlash. Landowners feared being cut off from the river, which many still use to water their stock. Long-established residents worried about the impact of such enforcement on cross-

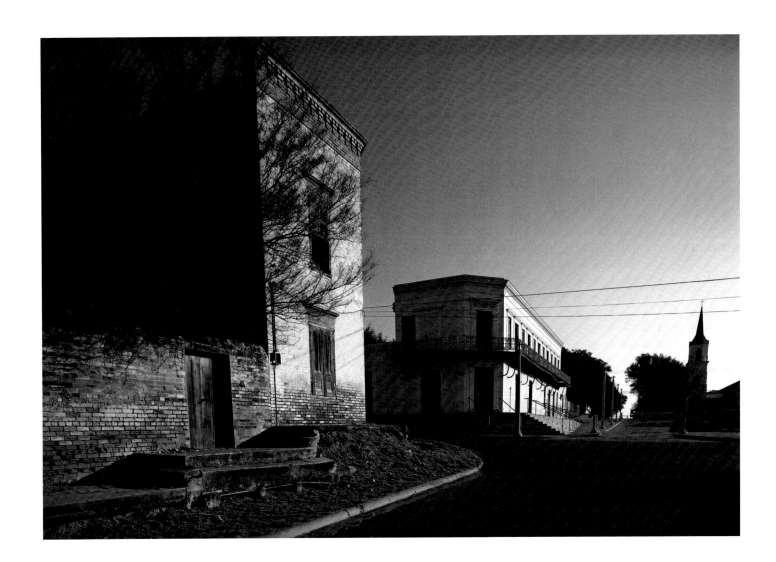

border family ties, and those hoping for greater development of ecotourism saw the proposed barrier as incompatible with their plans. Nearly everybody seemed to resent the use of images of the burning World Trade Center on a government document describing the border fence.

So this time the town's political establishment mobilized, but against border enforcement. A rally was held in the plaza, with a contingent kayaking from a few miles upstream. The former Starr County Democratic Party chairman compared the proposed barrier to the Berlin Wall and the Great Wall of China. Noting that the crowd was standing where Elia Kazan had filmed so much of *Viva Zapata!* he urged the emulation of Emiliano Zapata's resistance to dictatorship. Roma's mayor joined the group, walking out halfway across the bridge over the Rio Grande to shake hands with his counterpart from Miguel de Alemán in an assertion of the importance of their towns' continued ties. Another rally downriver the next month similarly invoked the region's border-straddling history. There the Oblate priest who had preceded Van Den Bussche in Roma condemned the wall (which threatened to cut off at least one nineteenth-century Oblate church from the rest of the country) as a symbol of something "vicious and soul-sickening." The march that he led featured a banner of Father Keralum, a crucifix, and a Texas flag. The region's past is alive and well in the minds of the present generation, but they are as conflicted as the rest of the United States in deciding how to reconcile their sense of who they are with the sometimes difficult realities of life on the border.

Conclusion

IF ANY OF THE MIGRANTS who once found refuge in Hugo Van Den Bussche's parish had the time to halt in their dash for the church doors to read an inscription, they would have found the following text on a plaque in the plaza:

> It is important to preserve and restore the remaining traces of generations past —But it is also vitally important for the present generation to leave its mark so that when the history of our own times is written, history will say of us: "They lived satisfying lives in a setting worthy of our heritage. Theirs was truly an age of hearts and order."

In recent decades, some of the more leisurely travelers who have been able to stop and read this ode to place-making have found something compelling in Roma, perhaps some sign that its builders lived in "an age of hearts and order." The novelist Larry McMurtry came through town at some point early in his career, long before the fame of *Lonesome Dove,* and chose it as the setting for the final scene in his 1972 novel *All My Friends Are Going to Be Strangers.* The novel's protagonist, Daniel Deck, an aspiring novelist unlucky in love, arrives in Roma late at night, after a depressing visit to the red-light district of Reynosa. He knows Roma as the town of *Viva Zapata!* and imagines "the sounds of goat bells" and a cantina "full of Zapatistas" as he walks through the old part of the town. Deck walks down the bluff with the manuscript of his novel, intent on destroying it and seemingly himself in the river. Immersed in

the depths of the channel, he thinks to himself, "it was always a borderland I had lived on, it seemed to me, a thin little strip between the country of the normal and the country of the strange," and wonders if "my true country was the borderland, anyway."[1]

A few years later, in 1978, the same year that the U.S. Bicentennial Commission put up the plaque, photographer Alex Webb passed through town and took a stark photograph in black and white. It is an image of beauty, but also of bleakness and abandonment. A silhouetted cat walks on a crumbling brick sidewalk, heading toward a long shadow cast by an electrical pole in the late afternoon sun on the plaza's gravel surface. The derelict Guerra store occupies the backdrop, dried weeds growing on its steps. Most of Webb's border photos feature people in the midst of bars, border fences, and official crossings, reflecting the interests in transience and cultural conflict that first brought him to the region as a twenty-two-year-old aspiring photographer. But something about the crumbled majesty of the plaza spoke to him, prompting him to make this very different photo the third image in a collection of his border photographs published twenty-five years after his visit.[2]

The plaza was similarly compelling for Mario Sánchez, who first encountered Roma in 1987, when he was sent by the Texas State Historical Commission to inspect the Roma-to-Miguel de Alemán suspension bridge. The plaza "has a magical kind of effect," he remembered decades later. "It was beckoning, very compelling," to walk down from the church to the promontory over the river. At the time, Sánchez knew little of the region's history, but he felt compelled by the power of the place to learn more. Convinced of the worth of the region's surviving material culture, he became the intellectual inspiration and leading advocate of an effort to preserve important cultural sites on both sides of the lower border. What came to be called Los Caminos

del Río ("roads of the river," literally) Heritage Project is an ambitious plan to use historic preservation to foster local pride, attract heritage tourism, and generate private investment in such ventures as restaurants, craftworks, and B&Bs in what remained a terribly poor region. Roma, one of the principals of Los Caminos del Río said, was the project's "crown jewel."[3]

In some ways the Caminos Project made substantial headway. Architects, historians, and historic preservationists in both countries could easily recognize that the region was distinct from anywhere else in either Mexico or the United States and that new construction threatened the older architectural incarnations of its singular history. The states of Texas and Tamaulipas invested money and logistical support in the endeavor, with municipalities joining the effort. Historic preservation arms of both federal governments also cooperated, designating numerous structures and areas (including the entire fifteen-block section of Roma encompassing the plaza) as National Historic Landmarks or Monumentos Históricos. A Dallas-based foundation, eager to contribute something to the poorest region of Texas, provided well over a million dollars in the early 1990s for the acquisition and restoration of some of the most important properties. Many of the plaza's buildings were rehabilitated— their load-bearing walls shored up, bricks mortared and tucked, walls painted, floors reconditioned. Thanks to those efforts, the plaza today looks much healthier than it does in Alex Webb's picture.[4]

And yet there is something profoundly ironic about standing in the plaza and reading the plaque. If it's easy to picture William Emory gazing from the bluff, Manuel Guerra in conversation with Enrique Portscheller on the steps of the Guerra Store, or the film crew working on *Viva Zapata!* then that's because the plaza is almost always empty. The notion that this is "a setting worthy of our heritage," as the

plaque proclaims, is an intellectual's vision but not a living reality. As in countless American towns and most cities, in Roma people hardly use the old downtown. There is a little traffic in and out of an office shared by the city government and the Caminos del Río Project, and occasionally a tourist comes by, drawn by the buildings or hoping for a glimpse of one of the birds that can be seen nowhere else in America other than South Texas. Every once in a while locals wander through, walking a dog or chaperoning children on bikes. But illicit crossings, small drug purchases, and assignations may outnumber these visits. And so the refurbished buildings sit, almost entirely empty, resuming their slow decay. With a population of about ten thousand, the town is bigger than it has ever been before, with enough people and enough capital to make the old downtown a living place rather than a dusty open-air museum. Yet not a single private establishment has been opened in the historic district surrounding the plaza. Most businesses are located on the state highway in typical-looking American strip developments so conventional that they are exceptionally unlikely to ever captivate novelists, photographers, or architects. Nobody will lament their decay, fight for their preservation, or erect monuments lauding them as embodiments of their culture's highest values.

The continued dereliction of the plaza may be another sign of just how American Roma is, more subtle but as telling as the flags in the cemeteries, military stickers on trucks, and the snapshots of young men and women deployed in Iraq that adorn the church bulletin board. The United States is a suburban civilization, not an urban one, as is more obvious to foreigners than natives. (One Mexican novelist even named his story of life north of the border *Ciudades desiertas,* "deserted cities.") Just across the river, Miguel de Alemán's plaza bustles with life. Its shops beckon visitors as couples sit on benches and old men read newspapers. In

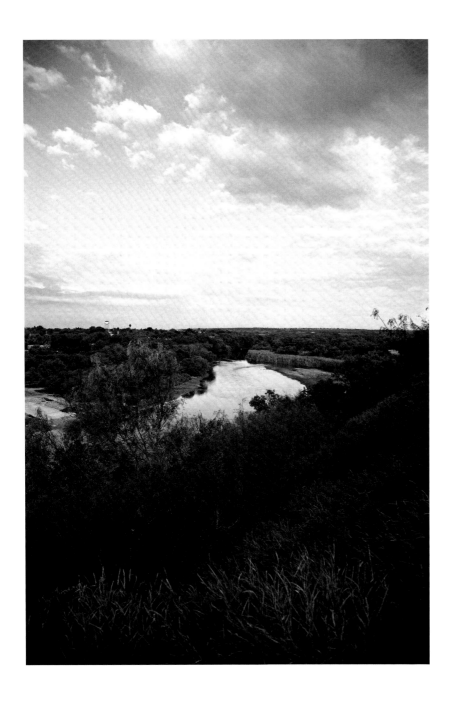

comparison to Roma, the town is young, poor, and architecturally undistinguished, yet also part of a country that knows how to be urban. No wonder that champions of city life in America hope that Hispanic migration might revitalize cities and re-acquaint Americans with the pleasures of vibrant urban space and pedestrian life.[5]

That Roma's historic district attracts too few outside tourists to support a single shop may be due to the proximity of the very border that prompted its creation. Despite the mass migration that has made border crossing a central chapter in the stories of millions of American families, despite the power that Portscheller's build-ings can still exert, despite the apotheosis of the border in song and fiction, almost everything that mass media communicate about places like Roma screams "stay away." Everybody who has tried to market Roma and towns like it—chambers of com-merce, the Caminos project, B&B owners, ecotourist operators—has had to confront the American public's perception of the border as a vulgar and dangerous place. Most, at least here, have lost the battle: it's hard to convince people to go to a place where, supposedly, drug cartels will gun you down, where you might pick up leprosy from disease-ridden "biological time bombs," where hungry children run barefoot in a land where everybody else is well-shod and sated, where maquilas defile an otherwise pristine environment. No wonder the mayor of Roma feels compelled to begin conversations with outsiders by telling them that he is a Vietnam veteran, that he loves America and would see no harm come to it.

And so at a casual glance Roma looks like a backwater, a scruffy, hardscrabble town. Those who do venture there are likely to stand where William Emory admired the view from upriver, where Confederate cotton made leading American and Mexi-can fortunes, where a German architect built to last in the old province of Nuevo Santander, where Jovita González witnessed the humor and resilience of her people,

where Elia Kazan filmed one of the founding myths of modern Mexico, where beloved local sons went to war and were returned to the earth, where for a century and a half Mexico and the United States have met. But they might not realize any of this: Roma is, after all, still just a small town on the northern bank of a river on the edge of two vast nations.

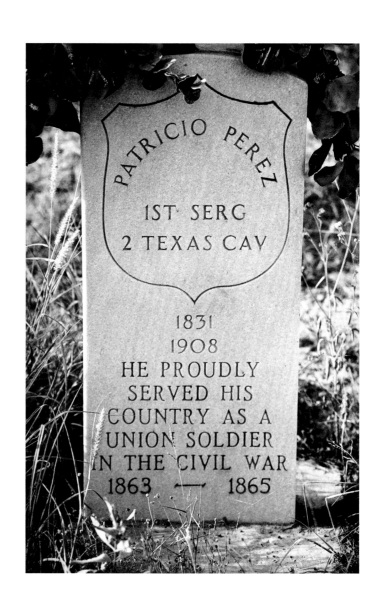

ACKNOWLEDGMENTS

THIS PROJECT BEGAN FOR ME when Jeff Gusky sent an email about his Roma photographs after hearing me talk about border history on the Dallas NPR station. I'll always be grateful to him for that.

Once I was hooked, a variety of people and institutions allowed me to pursue the research and writing. The fellows and faculty members associated with the William P. Clements Center for the Study of the Southwest at Southern Methodist University sparked my imagination about what this project could do. Funds from the Clements Department of History at Southern Methodist University allowed me to return to South Texas to see Roma, and underwrote the index and maps. In Roma I benefited from the hospitality, wisdom, and graciousness of Ceci Benavides, Noel Benavides, Carlos Rugerio, Rubén Rodriguez, and Manuela Gonzáles del Palacio.

During the writing phase, numerous phone interviews and face-to-face conversations helped me to round out my sense of Roma, its distinctive history, and the visions and projects that it had inspired. Thanks for that to Noel Benavides, Father Roy Snipes, Rogelio Ybarra, Ángel Alaníz, Mayo Peña, R. C. Salinas, Betty Pérez, Bruce Esterline, Mario Sánchez, Eric Ellman, Macarena Hernández, and Carlos Rugerio.

Miguel Ángel González de Quiroga, Patrick Kelly, Gabriel Martínez, and Ling Shiao pointed me to important secondary sources that helped me write key portions of some of the chapters.

The participants in a seminar on the border at the Dallas Center for Humanities and Culture graciously read a draft of the manuscript. Thanks to Beau Martin for his extensive and passionate feedback, and to Linda Garza Brown for encouragement and for the family history records that she shared with me.

A number of people took the time to read drafts of the manuscript, sharing their thoughts and advice, much of which I took to heart and some of which I chose to ignore or defy. Thanks to Glen Sample Ely, George Díaz, Andrew Graybill, Karl Jacoby, Pamela Walker, David Weber, and, of course, Jeff Gusky for these readings.

It's been a blessing to work with Yale University Press again. Chris Rogers, our editor, has been an enthusiastic backer of the project from the beginning, and I'm grateful to him for his hard work, especially his close reading of the manuscript and advice about how to incorporate the recommendations of the anonymous outside readers. Reader #2 earned my eternal gratitude for the most intellectually engaged and detailed peer review I've ever seen. Phillip King, Yale's manuscript editor, saved me from numerous errors of usage.

<div align="right">Benjamin Johnson</div>

Ten years ago, I had a toothache. I was working as a locum tenens staff emergency physician at a teaching hospital in McAllen, Texas. Dr. Mario Rodriguez, a gifted family practice intern, told me about his brother Rubén, a recent graduate of a top-ten dental school who had chosen to return to their hometown of Roma to practice dentistry. Roma is located about an hour's drive from McAllen in one of America's poorest counties.

I discovered that Rubén was an exceptional dentist. We became good friends. Rubén's practice was so successful that by 1999 he was able to build a new, state-of-the-art dental office.

Rubén's wife, Marlena, knew that I had been working on a series of photographs documenting the ruins of the destroyed civilization of Eastern European Jewry (which would become the book *Silent Places*). She asked me to create a series of photographs for Rubén's new office documenting the nineteenth-century ruins of the once-thriving inland seaport of Roma. Thus began this project.

I'm grateful to Marlena Rodriguez for conceiving the idea that launched this book. I thank Dr. Rubén Rodriguez for his patience and unwavering support throughout the seven years this project took. As a medical doctor, I admire the uncompromising quality of dental care he provides to a medically underserved community and view him as a model health-care practitioner, equally dedicated to his craft and to his community. I've remained his patient for over a decade, traveling five hundred miles from Dallas to Roma for routine dental care.

Noel Benavides has been an inspiration, information resource, friend, and guide to many of the places I photographed. I'm grateful for his unselfish sharing of time and knowledge about Starr County and his passion for its history, as well as the history of important eighteenth- and nineteenth-century sites located in nearby border communities in Mexico.

Architectural historian Carlos Rugerio has been a friend to the project and an invaluable source of historical information. Mauro Villareal, the director of the Main Street program for Rio Grande City, Texas, accompanied me to many fascinating urban and rural historical sites in Starr County. Bruce Esterline of

Dallas's Meadows Foundation shared first-hand knowledge about the preservation of historic buildings in Starr County and the founding of Los Caminos Del Río, a binational heritage project along the Rio Grande.

On March 2, 2004, I tuned in midway through a radio interview on the Glenn Mitchell show being broadcast on the NPR affiliate in Dallas, KERA. Within a very short time, I was completely engaged by the storytelling about Texas borderlands by Dr. Benjamin Heber Johnson. I didn't know where he was from but, by the end of his interview, was ready to travel anywhere in the United States to meet with him and ask him to collaborate with me on this book. Fortunately, he was a professor of history at SMU, located only a few miles away, and fortunately, he said yes after our first meeting. The collaboration has developed into a treasured friendship.

Jeffrey Gusky

NOTES

CHAPTER ONE
William Emory

1. William H. Emory, *Report on the United States and Mexican Boundary Survey* (Washington, D.C.: Cornelius Wendell, Printer, 1857), 1, 2, 14, 15, 23, 58, 84–85.
2. T. Robinson Warren, *Dust and Foam, or Three Oceans and Two Continents* (New York: Charles Scribner, 1858), 202, as quoted in Samuel Truett, *Fugitive Landscapes: The Forgotten History of the U.S.-Mexico Borderlands* (New Haven: Yale University Press, 2006), 15.
3. John Russell Bartlett, *Personal Narrative of Explorations and Incidents in Texas, New Mexico, California, Sonora, and Chihuahua, 1850–1853* (Chicago: Rio Grande Press, 1965; original edition, 1854), volume 2, 510.
4. Emory, *Report*, 64.
5. Ibid., 10–11.
6. Bartlett, *Personal Narrative*, volume 2, 300.
7. Ibid., volume 1, 183.
8. Emory, *Report*, 65, 69, 70.

CHAPTER TWO
José María García Sáens

1. *Handbook of Texas Online*, s.v. "Nuevo Santander," http://www.tsha.utexas.edu/handbook/online/articles/NN/usnue.html (accessed September 18, 2007).
2. José E. Zapata, "A Historical Archaeology of Roma, Texas" (M.A. Thesis, University of Texas at San Antonio, 2002), 30.
3. Armando C. Alonzo, *Tejano Legacy: Rancheros and Settlers in South Texas, 1734–1900* (Albuquerque: University of New Mexico Press, 1998), 75; LeRoy P. Graf, "The Economic History of the Lower Rio Grande Valley, 1820–1875" (Ph.D. Dissertation, Harvard University, 1942), 19.

4. Alonzo, *Tejano Legacy*, 44; Graf, "Economic History," 17, 99.

5. Emmanuel Domenech, *Missionary Adventures in Texas and Mexico: A Personal Narrative of Six Years' Sojourn in Those Regions* (London: Longman, Brown, Green, Longmans, and Roberts, 1858), 309; Andrés Tijerina, *Tejano Empire: Life on the South Texas Ranches* (College Station: Texas A & M University Press, 1998), 31; Graf, "Economic History," 435.

6. Carlos Rugerio, "La Villa de la Purísima Concepción de Mier en la Historia," unpublished essay, April 18, 2005, Roma Field Office of Los Caminos del Río, copy in author's possession; Carlos Rugerio, "El ladrillo en el devenir Histórico de la Frontera," June 24, 2005, unpublished essay in author's possession; Setha Low, *On the Plaza: The Politics of Public Space and Culture* (Austin: University of Texas Press, 2000), 103, 96.

7. Anthony Mora, "Mesillaros and Gringo Mexicans: The Changing Meanings of Race, Nation, and Space in Southwestern New Mexico, 1848–1912" (Ph.D. Dissertation, University of Notre Dame, 2002), chapter two, 15, 14, 12. The translation is Mora's.

8. Zapata, "Historical Archaeology," 36.

CHAPTER THREE
Charles Stillman

1. William H. Emory, *Report on the United States and Mexican Boundary Survey* (Washington, D.C.: Cornelius Wendell, Printer, 1857), 63.

2. John Winkler, *The First Billion: The Stillmans and the National City Bank* (New York: Vanguard, 1934), 23.

3. *Handbook of Texas Online*, s.v. "Stillman, Charles," http://www.tsha.utexas.edu/handbook/online/articles/SS/fst57.html (accessed June 18, 2005); Benjamin Heber Johnson, *Revolution in Texas: How a Forgotten Rebellion and Its Bloody Suppression Turned Mexicans into Americans* (New Haven: Yale University Press, 2003), 23.

4. Johnson, *Revolution in Texas*, 19; José E. Zapata, "A Historical Archaeology of Roma, Texas" (M.A. Thesis, University of Texas at San Antonio, 2002), 6.

5. Gerald Horne, *Black and Brown: African Americans and the Mexican Revolution* (New York: New York University Press, 2005), 14, 17; William D. Carrigan, *The Making of a Lynching Culture: Violence and Vigilantism in Central Texas, 1836–1916* (Urbana: University of Illinois Press, 2004); Sean Kelley, "'Mexico in His Head': Slavery and the Texas-Mexico Border, 1810–1860," *Journal of Social History* 37:3 (2004): 709–23; Johnson, *Revolution in Texas*, 8, 16. For contemporary estimates of general

slave flight, see John Hope Franklin and Loren Schweninger, *Runaway Slaves: Rebels on the Plantation* (New York: Oxford University Press, 1999), 279.

6. Juan Mora-Torres, *The Making of the Mexican Border: The State, Capitalism, and Society in Nuevo León, 1848–1910* (Austin: University of Texas Press, 2001), 28.

7. Quoted in Bernard DeVoto, *The Year of Decision, 1846* (Boston: Houghton Mifflin, 1942), 492.

8. Ronnie C. Tyler, *Santiago Vidaurri and the Southern Confederacy* (Austin: Texas State Historical Association, 1973), 105, 57.

9. Patrick Kelly, "Los Algodones (The Time of Cotton): War, Rebellion, and Trade on the Trans-Mississippi-Mexican Frontier, 1861–1867" (unpublished manuscript, 2002), 2; Mora-Torres, *Making of the Border*, 49; Zapata, "Historical Archaeology," 1.

10. Jerry Thompson and Lawrence T. Jones III, *Civil War and Revolution on the Rio Grande Frontier: A Narrative and Photographic History* (Austin: Texas State Historical Association, 2004), 30–31.

11. Ibid., 35.

12. United States War Department, *The War of the Rebellion: A Compilation of the Official Records of the Union and Confederate Armies*, series 1, volume 15 (Washington: Government Printing Office, 1886), 920.

13. Ibid., volume 26, part 2, 395.

14. Ibid., volume 26, part 1, 433, 831.

15. Thompson and Jones, *Civil War*, 38, 90.

16. Don Graham, *Kings of Texas: The 150-Year Saga of an American Ranching Empire* (New York: John Wiley and Sons, 2003), 105.

17. Alex Saragoza, *The Monterrey Elite and the Mexican State, 1880–1940* (Austin: University of Texas Press, 1988), 23, 62.

18. Johnson, *Revolution in Texas*, 17.

CHAPTER FOUR
Heinrich Portscheller

1. *Handbook of Texas Online*, s.v. "Portscheller, Heinrich," http://www.tsha.utexas.edu/handbook/online/articles/PP/fpo24.html (accessed September 18, 2007).

2. José E. Zapata, "A Historical Archaeology of Roma, Texas" (M.A. Thesis, University of Texas at San Antonio, 2002), 85.

3. Scott Cook, *Mexican Brick Culture in the Building of Texas, 1800s–1980s* (College Station: Texas A & M University Press, 1998), 19, 53.

4. Rufus B. Sage, as quoted in David J. Weber, ed., *Foreigners in Their Native Land: Historical Roots of the Mexican Americans* (Albuquerque: University of New Mexico Press, 1973), 72.

5. Benjamin Truman, *Semi-Tropical California* (San Francisco: A. L. Bancroft, 1874), 27; William Deverell, *Whitewashed Adobe: The Rise of Los Angeles and the Remaking of Its Mexican Past* (Berkeley: University of California Press, 2004), 135.

6. Chris Wilson, *The Myth of Santa Fe: Creating a Modern Regional Tradition* (Albuquerque: University of New Mexico Press, 1997), 56–57.

7. Deverell, *Whitewashed Adobe*, 135.

8. Cook, *Mexican Brick Culture*, 26.

9. Richard Rodriguez, *Days of Obligation: An Argument with My Mexican Father* (New York: Viking, 1993), 121–22.

10. Zapata, "Historical Archaeology," 6, 75–80.

11. Roma *Codis Historicus*, Southwestern Oblate Historical Archives, San Antonio, Texas, 53.

12. *Thirteenth Census of the United States*, volume 3: *Population*, 244.

13. Daniel Arreola, "Mexico Origins of Southwest Texas Mexican Americans, 1930," *Journal of Historical Geography* 19:1 (1993): 48–63.

14. Father Clos, 1884 report, *Codis Historicus;* Most Reverend A. Dontenwill, 1909 letter of visitation, Rio Grande City, and Roma *Codis Historicus*, volume 2, Southwestern Oblate Archive.

15. Robert Wright, *The Oblate Cavalry of Christ* (Rome: OMI General Postulation, 1998), 27.

CHAPTER FIVE
Jovita González

1. María Eugenia Cotera, "Jovita González Mireles: A Sense of History and Homeland," in *Latina Legacies: Identity, Biography, and Community,* ed. Vicki L. Ruiz and Virginia Sánchez Korrol (New York: Oxford University Press, 2005), 158–59; Jovita González, *Dew on the Thorn,* ed. José Limón (Houston: Arte Público, 1997), ix–x.

2. González, *Dew on the Thorn,* xi.

3. Jovita González, *The Woman Who Lost Her Soul and Other Stories,* ed. Sergio Reyna (Houston: Arte Público, 2000), xxiv.

4. Ibid., 50, 58, 68.

5. Jovita González, "Social Life in Cameron, Starr, and Zapata Counties" (M.A. Thesis, University of Texas at Austin, 1930), 58, 112, 88–89, 48.

6. Ibid., 78; interview with Mayo Peña, October 4, 2005.

7. Vincent Pérez, *Remembering the Hacienda: History and Memory in the Mexican American Southwest* (College Station: Texas A & M University Press, 2006), 99.

8. González, *Woman Who Lost Her Soul,* 109–15; González, *Dew on the Thorn.*

9. Benjamin Heber Johnson, *Revolution in Texas: How a Forgotten Rebellion and Its Bloody Suppression Turned Mexicans into Americans* (New Haven: Yale University Press, 2003).

10. *Handbook of Texas Online,* s.v. "Tobin, William Gerard," http://www.tshaonline.org/handbook/online/ articles/TT/fto4.html (accessed January 16, 2008); Robb Walsh, *The Tex-Mex Cookbook: A History in Recipes and Photos* (New York: Broadway, 2004), xvii, 66, 64.

11. Scott Cook, *Mexican Brick Culture in the Building of Texas, 1800s–1980s* (College Station: Texas A & M University Press, 1998), 7; Chris Wilson, *The Myth of Santa Fe: Creating a Modern Regional Tradition* (Albuquerque: University of New Mexico Press, 1997), 112–15.

12. Duncan Aikman quoted in Paul J. Vanderwood, *Juan Soldado: Rapist, Murderer, Martyr, Saint* (Durham: Duke University Press, 2004), 100; Art Spiegelman, "Those Dirty Little Comics," in *Tijuana Bibles: Art and Wit in America's Forbidden Funnies, 1930s–1950s,* ed. Bob Adelman (New York: Simon and Schuster, 1997), 6; Gene Fowler and Bill Crawford, *Border Radio: Quacks, Yodelers, Pitchmen, Psychics, and Other Amazing Broadcasters of the American Airwaves* (Austin: Texas Monthly Press, 1987). See also the album Los Super Seven, *Heard It on the X* (Telarc, 2005).

13. Clipping in OMI archive: Virgil Lott, "Roma, a City of Peace and Quiet, Is Picturesque Home of Local Writer," *The Mission Enterprise,* April 21, 1938.

14. Cotera, "Jovita González Mireles," 169.

Gilberto Garza

1. For enlistment records, see United States Army, Electronic Army Serial Number Merged File, ca. 1938–1946, Enlistment Records, in World War II Army Enlistment Records, U.S. National Archives, Record Group 64, online. These records note the enlistment of 729 men from Starr County from 1938 to 1946, almost all of them during the war, especially 1942 and 1943. The 1940 U.S. census counted 1,763 men

in the county from ages twenty to thirty-four. See United States Bureau of the Census, *Sixteenth Census of the United States, 1940: Population*, Table 22, p. 849.

2. U.S. Army, Electronic Army Serial Number Merged File.

3. Eric Bergerud, *Touched with Fire: The Land War in the South Pacific* (New York: Viking, 1996), 61, 70, 440, 450.

4. Dan Van der Vat, *The Pacific Campaign: World War II, the U.S.-Japanese Naval War, 1941–1945* (New York: Simon and Schuster, 1991), 367–69.

5. U.S. Army, Electronic Army Serial Number Merged File; United States Army, *World War II Honor List of Dead and Missing Army and Army Air Forces Personnel from Texas, 1946* (on the Web at http://media.nara .gov/media/images/29/20/29-1915a.gif, accessed September 18, 2007).

6. Patrick J. Carroll, *Felix Longoria's Wake: Bereavement, Racism, and the Rise of Mexican American Activism* (Austin: University of Texas, 2003), 28.

7. Maggie Rivas-Rodriguez, "Newspaper Coverage of the Three Rivers Incident," in *Mexican Americans and World War II*, ed. Maggie Rivas-Rodriguez (Austin: University of Texas Press, 2005), 203.

8. Robert Caro, "The Compassion of Lyndon Johnson," *New Yorker*, April 1, 2002, 66.

9. Carroll, *Felix Longoria's Wake*, 143.

10. Ibid., 189, 181.

11. Account from 1926 of Roma visitation by Rev. Fr. Belle, Roma Codex, Oblate Archive.

12. United States Bureau of the Census, *Fourteenth Census of the United States: Population* (Washington, D.C., 1921), 1011.

13. Mayo Peña interview; interview with R. C. Salinas, August 13, 2007; interview with Noel Benavides, July 7, 2005.

14. David Romo, "The Mayor's Silk Underwear: Old and New Fears at the El Paso–Juárez International Bridge," *Texas Observer*, May 7, 2004, 18.

15. Mayo Peña interview; interview with Noel Benavides, May 14, 2005. For the general willingness of border enforcement officers to allow for local crossings, see S. Deborah Kang, "Crossing the Line: The INS and the Federal Regulation of the Mexican Border," in *Bridging National Borders in North America*, ed. Andrew Graybill and Benjamin Johnson (Durham: Duke University Press, forthcoming).

16. David Montejano, "The Beating of Private Aguirre," in *Mexican Americans and World War II*, ed. Maggie Rivas-Rodriguez (Austin: University of Texas Press, 2005), 51.

17. Ibid., 41; George Sánchez, *Becoming Mexican-American: Ethnicity, Culture, and Identity in Chicano Los Angeles, 1900–1945* (New York: Oxford University Press, 1993), 267.

CHAPTER SEVEN

Elia Kazan

1. William Baer, ed., *Elia Kazan: Interviews* (Jackson: University Press of Mississippi, 2000), 167; Elia Kazan, *A Life* (New York: Knopf, 1988), 431–33; Jeff Young, *Kazan: The Master Director Discusses His Films; Interviews with Elia Kazan* (New York: Newmarket, 1999), 101, 108.
2. Kazan, *A Life*, 431; Young, *Kazan*, 106; United States Bureau of the Census, *Seventeenth Census of the United States: Population*, 216.
3. Scott Cook, *Mexican Brick Culture in the Building of Texas, 1800s–1980s* (College Station: Texas A & M University Press, 1998), 54, 92.

CHAPTER EIGHT

Hugo Van Den Bussche

1. Benjamin Alire Sáenz, *Dreaming the End of the War* (Port Townsend, Wash.: Copper Canyon, 2006).
2. Richard Marosi, "Place Names Narrate Migrants' Saga," *Los Angeles Times*, May 10, 2005.
3. Daniel Gonz Lez and Susan Carroll, "Siege on Border," *Arizona Republic*, June 19, 2005; Amanda Shorey, "Migrant Smugglers Get Creative in Face of Increased Enforcement," Associated Press, April 3, 2005.
4. Carlos Fuentes, *The Crystal Frontier* (New York: Farrar, Straus, and Giroux, 1997; originally published in Mexico as *La frontera de cristal: Una novela en nueve cuentos*, by Aguilar, Altea Taurus, Alfraguara, 1995).
5. Cormac McCarthy, *Blood Meridian; Or, the Evening Redness in the West* (New York: Random House, 1985); Cormac McCarthy, *All The Pretty Horses* (New York: Knopf, 1992); Cormac McCarthy, *The Crossing* (New York: Knopf, 1994); Cormac McCarthy, *Cities of the Plain* (New York: Knopf, 1998); Cormac McCarthy, *No Country for Old Men* (New York: Knopf, 2005); Bruce Springsteen, *The Ghost of Tom Joad* (Sony, 1995).
6. George Thomas Clark, "Minutemen on the U.S.A.-Mexican Border," April 11, 2005, http://www.mexidata.info/id456.html, accessed September 21, 2007.
7. Robert Lee Maril, *Patrolling Chaos: The U.S. Border Patrol in Deep South Texas* (Lubbock: Texas Tech University Press, 2004), 65.
8. Dulcinea Cuellar, "Safer by the Minute?" *McAllen Monitor*, June 21, 2005; Noel Benavides, interview, July 7, 2005; Leo Banks, "Under Siege," *Tucson Weekly*, March 10, 2005.

9. Bonnie Pfister, "Drug Ring Brothers Get Life Terms," *San Antonio Express-News*, May 4, 2001; Peter Andreas, *Border Games: Policing the U.S.-Mexico Divide* (Ithaca: Cornell University Press, 2000), 40–45; Maril, *Patrolling Chaos*, 12; interview with Father Roy Snipes, OMI, August 27, 2007.

10. Andreas, *Border Games*, 75–77; Maril, *Patrolling Chaos*, 87.

11. Sean Marciniack, "Church Sanctuary: Immigrants Play Cat and Mouse with Agents, Using Roma Chapel as Safety Zone," *McAllen Monitor*, Sunday, August 12, 2001.

12. Maril, *Patrolling Chaos*, 251.

CONCLUSION

1. Larry McMurtry, *All My Friends Are Going to Be Strangers* (New York: Simon and Schuster, 1972), 275, 285.

2. Alex Webb, *Crossings: Photographs from the U.S.-Mexico Border* (New York: Monacelli, 2003); Margaret Regan, "Capturing Crossings: Alex Webb's Photography Shows a Quarter-Century of Life Along the Border," *Tucson Weekly*, April 21, 2005.

3. Interview with Mario Sánchez, August 11, 2007; interview with Bruce Esterline, August 7, 2007.

4. Esterline interview; Los Caminos del Río Heritage Project and the Texas Historical Commission, *A Shared Experience: The History, Architecture, and Historic Designations of the Lower Rio Grande Heritage Corridor* (Austin: Texas State Historical Commission, 1994).

5. José Agustín, *Ciudades desiertas* (Mexico City: Alfaguerra, 1994); Mike Davis, *Magical Urbanism: Latinos Reinvent the U.S. Big City* (New York: Verso, 2000); Lawrence Herzog, *From Aztec to High Tech: Architecture and Landscape Across the Mexico-United States Border* (Baltimore: Johns Hopkins University Press, 1999).

BIBLIOGRAPHY

GOVERNMENT DOCUMENTS

Thirteenth Census of the United States. Volume 3: *Population.*

United States Army. Electronic Army Serial Number Merged File, ca. 1938–1946, Enlistment Records, in World War II Army Enlistment Records, U.S. National Archives, Record Group 64.

United States Army. *World War II Honor List of Dead and Missing Army and Army Air Forces Personnel from Texas, 1946.* On the Web at http://media.nara.gov/media/images/29/20/29-1915a.gif, accessed September 18, 2007.

United States War Department. *The War of the Rebellion: A Compilation of the Official Records of the Union and Confederate Armies.* Series 1, volume 15 (Washington: Government Printing Office, 1886).

INTERVIEWS

Benavides, Noel. May 14, 2005; July 7, 2005.

Esterline, Bruce. August 7, 2007.

Salinas, R. C. August 13, 2007.

Sánchez, Mario. August 11, 2007.

Snipes, Father Roy, OMI. August 27, 2007.

PRIMARY AND SECONDARY SOURCES

Agustín, José. *Ciudades desiertas.* Mexico City: Alfaguerra, 1994.

Alonzo, Armando C. *Tejano Legacy: Rancheros and Settlers in South Texas, 1734–1900.* Albuquerque: University of New Mexico Press, 1998.

Andreas, Peter. *Border Games: Policing the U.S.-Mexico Divide.* Ithaca: Cornell University Press, 2000.

Arreola, Daniel. "Mexico Origins of Southwest Texas Mexican Americans, 1930." *Journal of Historical Geography* 19:1 (1993): 48–63.

Baer, William, ed. *Elia Kazan: Interviews.* Jackson: University Press of Mississippi, 2000.

Banks, Leo. "Under Siege." *Tucson Weekly,* March 10, 2005.

Bartlett, John Russell. *Personal Narrative of Explorations and Incidents in Texas, New Mexico, California, Sonora, and Chihuahua, 1850–1853.* Chicago: Rio Grande Press, 1965 (original edition, 1854).

Bergerud, Eric. *Touched with Fire: The Land War in the South Pacific.* New York: Viking, 1996.

Caro, Robert. "The Compassion of Lyndon Johnson." *New Yorker,* April 1, 2002.

Carrigan, William D. *The Making of a Lynching Culture: Violence and Vigilantism in Central Texas, 1836–1916.* Urbana: University of Illinois Press, 2004.

Carroll, Patrick J. *Felix Longoria's Wake: Bereavement, Racism, and the Rise of Mexican American Activism.* Austin: University of Texas Press, 2003.

Clark, George Thomas. "Minutemen on the U.S.A.-Mexican Border," April 11, 2005. http://www.mexidata.info/id456.html, accessed September 21, 2007.

Cook, Scott. *Mexican Brick Culture in the Building of Texas, 1800s–1980s.* College Station: Texas A & M University Press, 1998.

Cotera, María Eugenia. "Jovita González Mireles: A Sense of History and Homeland." In *Latina Legacies: Identity, Biography, and Community,* ed. Vicki L. Ruiz and Virginia Sánchez Korrol. New York: Oxford University Press, 2005.

Cuellar, Dulcinea. "Safer by the Minute?" *McAllen Monitor,* June 21, 2005.

Davis, Mike. *Magical Urbanism: Latinos Reinvent the U.S. Big City.* New York: Verso, 2000.

Deverell, William. *Whitewashed Adobe: The Rise of Los Angeles and the Remaking of Its Mexican Past.* Berkeley: University of California Press, 2004.

DeVoto, Bernard. *The Year of Decision, 1846.* Boston: Houghton Mifflin, 1942.

Domenech, Emmanuel. *Missionary Adventures in Texas and Mexico: A Personal Narrative of Six Years' Sojourn in Those Regions.* London: Longman, Brown, Green, Longmans, and Roberts, 1858.

Emory, William H. *Report on the United States and Mexican Boundary Survey.* Washington, D.C.: Cornelius Wendell, Printer, 1857.

Fowler, Gene, and Bill Crawford. *Border Radio: Quacks, Yodelers, Pitchmen, Psychics, and Other Amazing Broadcasters of the American Airwaves.* Austin: Texas Monthly Press, 1987.

Franklin, John Hope, and Loren Schweninger. *Runaway Slaves: Rebels on the Plantation.* New York: Oxford University Press, 1999.

Fuentes, Carlos. *The Crystal Frontier.* New York: Farrar, Straus, and Giroux, 1997. Originally published in Mexico as *La frontera de cristal: Una novela en nueve cuentos,* by Aguilar, Altea Taurus, Alfraguara, 1995.

González, Jovita. *Dew on the Thorn,* ed. José Limón. Houston: Arte Público, 1997.

González, Jovita. "Social Life in Cameron, Starr, and Zapata Counties." M.A. Thesis, University of Texas at Austin, 1930.

González, Jovita. *The Woman Who Lost Her Soul and Other Stories,* ed. Sergio Reyna. Houston: Arte Público, 2000.

Graf, LeRoy P. "The Economic History of the Lower Rio Grande Valley, 1820–1875." Ph.D. Dissertation, Harvard University, 1942.

Graham, Don. *Kings of Texas: The 150-Year Saga of an American Ranching Empire.* New York: John Wiley and Sons, 2003.

Handbook of Texas Online, s.v. "Nuevo Santander," http://www.tsha.utexas.edu/handbook/online/articles/NN/usnue.html (accessed September 18, 2007).

Handbook of Texas Online, s.v. "Portscheller, Heinrich," http://www.tsha.utexas.edu/handbook/online/articles/PP/fpo24.html (accessed September 18, 2007).

Handbook of Texas Online, s.v. "Stillman, Charles," http://www.tsha.utexas.edu/handbook/online/articles/SS/fst57.html (accessed June 18, 2005).

Handbook of Texas Online, s.v. "Tobin, William Gerard," http://www.tshaonline.org/handbook/online/articles/TT/fto4.html (accessed January 16, 2008).

Herzog, Lawrence. *From Aztec to High Tech: Architecture and Landscape Across the Mexico–United States Border.* Baltimore: Johns Hopkins University Press, 1999.

Horne, Gerald. *Black and Brown: African Americans and the Mexican Revolution.* New York: New York University Press, 2005.

Johnson, Benjamin Heber. *Revolution in Texas: How a Forgotten Rebellion and Its Bloody Suppression Turned Mexicans into Americans.* New Haven: Yale University Press, 2003.

Kang, S. Deborah. "Crossing the Line: The INS and the Federal Regulation of the Mexican Border." In *Bridging National Borders in North America,* ed. Andrew Graybill and Benjamin Johnson. Durham: Duke University Press, forthcoming.

Kazan, Elia. *A Life.* New York: Knopf, 1988.

Kelley, Sean. "'Mexico in His Head': Slavery and the Texas-Mexico Border, 1810–1860." *Journal of Social History* 37:3 (2004): 709–23.

Kelly, Patrick. "Los Algodones (The Time of Cotton): War, Rebellion, and Trade on the Trans-Mississippi-Mexican Frontier, 1861–1867," unpublished manuscript, 2002.

Lez, Daniel Gonz, and Susan Carroll. "Siege on Border." *Arizona Republic,* June 19, 2005.

Los Caminos del Río Heritage Project and the Texas Historical Commission. *A Shared Experience: The History, Architecture, and Historic Designations of the Lower Rio Grande Heritage Corridor.* Austin: Texas State Historical Commission, 1994.

Los Super Seven. *Heard It on the X.* Telarc, 2005.

Lott, Virgil. "Roma, a City of Peace and Quiet, Is Picturesque Home of Local Writer." *The Mission Enterprise,* April 21, 1938.

Low, Setha. *On the Plaza: The Politics of Public Space and Culture.* Austin: University of Texas Press, 2000.

McCarthy, Cormac. *All The Pretty Horses.* New York: Knopf, 1992.

McCarthy, Cormac. *Blood Meridian; Or, the Evening Redness in the West.* New York: Random House, 1985.

McCarthy, Cormac. *Cities of the Plain.* New York: Knopf, 1998.

McCarthy, Cormac. *The Crossing.* New York: Knopf, 1994.

McCarthy, Cormac. *No Country for Old Men.* New York: Knopf, 2005.

McMurtry, Larry. *All My Friends Are Going to Be Strangers.* New York: Simon and Schuster, 1972.

Marciniack, Sean. "Church Sanctuary: Immigrants Play Cat and Mouse with Agents, Using Roma Chapel as Safety Zone." *McAllen Monitor,* August 12, 2001.

Maril, Robert Lee. *Patrolling Chaos: The U.S. Border Patrol in Deep South Texas.* Lubbock: Texas Tech University Press, 2004.

Marosi, Richard. "Place Names Narrate Migrants' Saga." *Los Angeles Times,* May 10, 2005.

Montejano, David. "The Beating of Private Aguirre." In *Mexican Americans and World War II,* ed. Maggie Rivas-Rodriguez. Austin: University of Texas Press, 2005.

Mora, Anthony. "Mesillaros and Gringo Mexicans: The Changing Meanings of Race, Nation, and Space in Southwestern New Mexico, 1848–1912." Ph.D. Dissertation, University of Notre Dame, 2002.

Mora-Torres, Juan. *The Making of the Mexican Border: The State, Capitalism, and Society in Nuevo León, 1848–1910.* Austin: University of Texas Press, 2001.

Pérez, Vincent. *Remembering the Hacienda: History and Memory in the Mexican American Southwest.* College Station: Texas A & M University Press, 2006.

Pfister, Bonnie. "Drug Ring Brothers Get Life Terms." *San Antonio Express-News,* May 4, 2001.

Regan, Margaret. "Capturing Crossings: Alex Webb's Photography Shows a Quarter-Century of Life Along the Border." *Tucson Weekly,* April 21, 2005.

Rivas-Rodriguez, Maggie. "Newspaper Coverage of the Three Rivers Incident." In *Mexican Americans and World War II,* ed. Maggie Rivas-Rodriguez. Austin: University of Texas Press, 2005.

Rodriguez, Richard. *Days of Obligation: An Argument with My Mexican Father.* New York: Viking, 1993.

Romo, David. "The Mayor's Silk Underwear: Old and New Fears at the El Paso–Juárez International Bridge." *Texas Observer,* May 7, 2004.

Rugerio, Carlos. "El ladrillo en el devenir Histórico de la Frontera," June 24, 2005, unpublished essay in author's possession.

Rugerio, Carlos. "La Villa de la Purísima Concepción de Mier en la Historia," unpublished essay, April 18, 2005, Roma Field Office of Los Caminos del Río.

Sáenz, Benjamin Alire. *Dreaming the End of the War.* Port Townsend, Wash.: Copper Canyon, 2006.

Sánchez, George. *Becoming Mexican-American: Ethnicity, Culture, and Identity in Chicano Los Angeles, 1900–1945.* New York: Oxford University Press, 1993.

Saragoza, Alex. *The Monterrey Elite and the Mexican State, 1880–1940.* Austin: University of Texas Press, 1988.

Shorey, Amanda. "Migrant Smugglers Get Creative in Face of Increased Enforcement." Associated Press, April 3, 2005.

Spiegelman, Art. "Those Dirty Little Comics." In *Tijuana Bibles: Art and Wit in America's Forbidden Funnies, 1930s–1950s,* ed. Bob Adelman. New York: Simon and Schuster, 1997.

Springsteen, Bruce. *The Ghost of Tom Joad.* Sony Records, 1995.

Thompson, Jerry, and Lawrence T. Jones III. *Civil War and Revolution on the Rio Grande Frontier: A Narrative and Photographic History.* Austin: Texas State Historical Association, 2004.

Tijerina, Andrés. *Tejano Empire: Life on the South Texas Ranches.* College Station: Texas A & M University Press, 1998.

Truett, Samuel. *Fugitive Landscapes: The Forgotten History of the U.S.-Mexico Borderlands.* New Haven: Yale University Press, 2006.

Truman, Benjamin. *Semi-Tropical California.* San Francisco: A. L. Bancroft, 1874.

Tyler, Ronnie C. *Santiago Vidaurri and the Southern Confederacy.* Austin: Texas State Historical Association, 1973.

Van der Vat, Dan. *The Pacific Campaign: World War II, the U.S.-Japanese Naval War, 1941–1945.* New York: Simon and Schuster, 1991.

Vanderwood, Paul. *Juan Soldado: Rapist, Murderer, Martyr, Saint.* Durham: Duke University Press, 2004.

Walsh, Robb. *The Tex-Mex Cookbook: A History in Recipes and Photos.* New York: Broadway, 2004.

Warren, T. Robinson. *Dust and Foam, or Three Oceans and Two Continents.* New York: Charles Scribner, 1858.

Webb, Alex. *Crossings: Photographs from the U.S.-Mexico Border.* New York: Monacelli, 2003.

Weber, David J., ed. *Foreigners in Their Native Land: Historical Roots of the Mexican Americans.* Albuquerque: University of New Mexico Press, 1973.

Wilson, Chris. *The Myth of Santa Fe: Creating a Modern Regional Tradition.* Albuquerque: University of New Mexico Press, 1997.

Winkler, John. *The First Billion: The Stillmans and the National City Bank.* New York: Vanguard, 1934.

Wright, Robert. *The Oblate Cavalry of Christ.* Rome: OMI General Postulation, 1998.

Young, Jeff. *Kazan: The Master Director Discusses His Films; Interviews with Elia Kazan.* New York: Newmarket, 1999.

Zapata, José E. "A Historical Archaeology of Roma, Texas." M.A. Thesis, University of Texas at San Antonio, 2002.

PHOTOGRAPHS

INDEX

adobe, 84–85, 87, 90, 113–14, 138

African Americans, 44, 52, 67, 69, 110, 137

agriculture, 23, 40–41, 44, 146, 148. *See also* ranching

Agualeguas (Mexico), 94

Alamo, 111

aljibe, 44

All My Friends Are Going to Be Strangers (McMurtry), 173–74

Anglos: Confederate supporters in Civil War, 75; culture of, 90, 97; interest in aspects of Hispanic culture, 111, 113–14; prejudice against Hispanics, 24, 27–28, 31, 52, 64, 66–67, 84, 85, 87, 90, 102, 106, 109–11, 122–23, 126–28, 130, 137–38; as Roma residents, 67, 83, 90–91, 97, 137, 138; as Texas minority, 10; as Texas settlers, 24, 27–28, 33, 52, 56–57, 67, 91, 111. *See also* intermarriage

Apache Indians, 21, 48, 54

Arizona, x, 51, 153, 157, 163

Arlington National Cemetery, 127, 128, 130, 141

Aztecs, 48, 49

Bagdad (Texas), 71

bajadas, 44

Bartlett, John Russell, 20, 21, 23–24, 27, 28, 33, 64

beer (Mexican), 77

Benavides, Santos, 75, 81

border(s): as American places, ix–xi, 15, 176, 178; artistic treatments of, 160, 162, 173–74; as Civil War issue, 70–72, 75; commerce across, 59–79, 106, 151, 165–66; creation of Mexican-American, 10, 17, 20–21; as crossing Mexican people, in Texas, xi, 51–52, 101, 102; families on both sides of, 6, 96–97, 132, 134, 153, 170–71; as frontier, ix; isolation of, from the rest of the United States, 94, 96–97; as linking countries, 179; people as crossing, 6, 10, 12, 15, 51, 52, 84, 101, 153, 154–55, 157, 159–60, 162; preservation of historic culture of, 173–79; reputation of, ix, 12, 15, 114, 117, 118, 178; ties of, to the rest of the United States, 130, 132, 141, 145–46, 148, 154; tightening of, 134, 151, 154–55, 157, 159; walls along, 166, 168–71. *See also* Border Patrol; immigrants and migrants; Mexico; Rio Grande; Roma (Texas); surveyors; United States

Border Patrol, 12, 134, 151, 155, 157, 159, 160, 163, 168

Bracero program, 146

Bradstreet, Anne, 109

Brando, Marlon, 143, 151

brick making (Mexican), 83–85, 87, 90, 113, 138, 151

Brownsville (Texas), 1, 64, 66–67, 76, 94

United States: border bridges built by, 134, 171, 174; boundary between Mexico and, 10, 17, 20–21; citizenship in, 51, 56; in González's works, 106, 108–9; Hispanic population in, 10, 153–54; ideals of, 75, 108–9, 146; as imperial power, 20, 31; Mexico's ties with, 145–46, 148, 153, 171; as occupying Mexican territory, 12, 132; regional divisions in, 20, 24, 52; Roma as purchased by, x–xi, 1; Roma as shaping, 6, 10, 15; slavery in, 20, 44, 52, 67, 69; and Texas Revolution, 54–55; township system in, 40. *See also* border(s); Border Patrol; *names of specific wars*

U.S. Army, 17, 21, 54, 66, 125–28, 130

U.S. Bicentennial Commission, 174

U.S. Department of Homeland Security, 168

U.S.-Mexican War (1848), 17, 64, 71. *See also* Treaty of Guadalupe Hidalgo

University of Texas (Austin), 102, 110

urban communities, 113, 176, 178

Urrea, Luis Alberto, ix–xi

Van Den Bussche, Hugo, 6, 154, 157, 160, 163, 166–68, 171, 173

Vela, Ysidro, 75

Victoria (Texas), 157

Vietnam War, 178

violence: between Anglos and Hispanics, 52, 64, 66–67, 106, 111, 128, 132, 138; fear of, from migrants, 163, 165

Viva Zapata! (film), 143, 145–46, 148, 153, 171, 173, 175, 179

voting irregularities, in Texas, 10, 75, 108, 110, 138, 141

walls, along border, 166, 168–71

War of 1812, 20

Webb, Alex, 174, 175

white race, 28, 31, 64, 84–85, 125

women's roles, 106–7, 109

World's Columbian Exposition (Chicago), 111

World Trade Center (New York), 171

World War I, 106, 132

World War II, 125–28, 130, 137–38, 141, 146, 151

Zapata, Emiliano, 6, 143, 145, 148, 171

Zapata County (Texas), 75, 111

Zyklon B, 137

Fugitive Landscapes, by Samuel Truett
Bárbaros, by David J. Weber